COLOR

for Ellen

COLOR

A WORKSHOP FOR ARTISTS & DESIGNERS

THIRD EDITION LAURENCE KING PUBLISHING DAVID HORNUNG

Published in Great Britain by
Laurence King Student & Professional
An imprint of Quercus Editions Ltd
Carmelite House
50 Victoria Embankment
London EC4Y 0DZ

An Hachette UK company

First edition published in 2004
Second edition published in 2012
This edition published in 2021
Reprinted in 2022

A CIP catalogue record for this book is available
from the British Library

US TPB ISBN 978 1 78627 660 5
UK TPB ISBN 978 1 78627 634 6

10 9 8 7 6 5 4

Commissioning Editor: Kara Hattersley-Smith
Senior Editor: Andrew Roff
Copy Editor: Alison Effeny
Picture Researcher: Peter Kent
Design: Lozana Rossenova
Cover design: Lozana Rossenova
Cover image: Deborah Zlotsky, Tragedy tomorrow, comedy tonight,
oil on canvas, 2012 (detail)

Printed and bound in China by C&C Offset Printing Co., Ltd.

Papers used by Quercus are from well-managed forests and other responsible sources.

CONTENTS

* Videos can be accessed by scanning the QR codes on the relevant page or visiting https://www.laurenceking.com/colour-3rd-edition/ under the heading Downloads & Extras

* Color terms that can be found in the Illustrated Glossary appear in capital letters, usually where they are first encountered in the text.

ACKNOWLEDGMENTS

In making this third edition of *Color*, I have benefited from the help and support of many key individuals. First among these is Laurence King, whom I thank for the opportunity to update the second edition with major revisions to text and illustration.

I would also like to recognize the contribution of Kara Hattersley-Smith, Commissioning Editor at Laurence King, who has supported my work on all three editions and guided me through the proposal process once again with her characteristic warmth and efficiency. Thanks, too, to Senior Editor Andrew Roff, who helped me make the deadlines and steered me wisely through the intricacies of this book's journey into print.

Alison Effeny's insightful copy-editing improved my writing and saved me from public embarrassment. Simon Walsh, Production Manager, ensured that the color throughout the book is as good as it can be; and Peter Kent, Picture Researcher, procured the images that I needed from outside sources to illustrate the text. Thanks also to my reviewers, whose critical observations were helpful in planning this edition, and to my colleague Jennifer Maloney for her many insights and advice.

Lozana Rossenova's book design is integral to this edition and I thank her for her creativity, skill, and brilliance, and for being so easy to work with.

I would also like to thank Anne de Mere and Jenny Woodward for their beautiful work on the videos that accompany this book.

Finally, I want to thank William Itter who, through his mentorship in my first college appointment at Indiana University, profoundly influenced my approach to teaching. Bill had been at Yale and knew both Anni and Josef Albers. Like them, he balanced rigorous intellect with poetic intuition in both studio and classroom. Among the many things I learned from him was that, before assigning a project, I needed to make it myself. His dedication to unveiling for students the formal interplay of design elements inspired me as a young teacher and continues to do so today.

FOREWORD

In 2001, David Hornung showed me the prototype for *Handmade Light*, a book he was writing based on the color course he first developed at the Rhode Island School of Design. David's model combined an accessible treatment of how we perceive color with an in-depth practical exploration of how color functions in art and design. To help him test his ideas, I began working through several of the projects he was creating for the book and immediately grasped the usefulness of his approach.

Handmade Light evolved into *Color: A Workshop for Artists and Designers*, whose first edition was published in 2005. The course of study David presented in the book differed from other color courses in two important ways. First, instead of using pre-printed colored papers, students created their own supply of colored swatches by mixing water-based paint. Second, David explained the visual characteristics of color with practical application in mind. One of the great frustrations in color mixing is that it can feel like a series of accidents: an experience of continuous experimentation without truly understanding why or how you arrive at a color. David's book provided the ingredients you need to experiment with purpose.

Color: A Workshop for Artists and Designers presents color principles and concepts in a series of practical assignments which become the focus of discussion. In addition to a formal understanding of its properties and behaviors, each student develops a personal relationship to color that she can bring into her studio practice.

At the back of the book is an Illustrated Glossary of the color terms used throughout the lessons. Mastery of these terms makes meaningful and rewarding classroom communication possible. One of my favorite teaching exercises is one David designed to test that mastery. I select a colored swatch and, without showing it to the students, describe the color's hue, value, and saturation. The students attempt to mix the color as I have described it and then we compare the swatches. I find this exercise immensely satisfying because it is where I get to see concrete evidence that the students understand the concepts presented in David's book. And they seem to enjoy the challenge.

I have used *Color: A Workshop for Artists and Designers* in my color classes at Adelphi University, where David and I are colleagues, for ten years. We continue to meet regularly to talk about course-related issues and these color discussions have had a profound impact on me as both painter and educator. David's ideas about teaching color are always evolving. His projects are grounded in years of studio and classroom experience and are accessible to students and artists at all levels.

Color: A Workshop for Artists and Designers transforms the student's ability to examine, describe, and discuss color as it connects theory with practice. Teaching this workshop approach has been a continuous source of insight over the years for me as well.

—Jennifer Maloney

INTRODUCTION

My lifelong interest in color as a subject of serious study was ignited when, as an art student, I was introduced to the beautiful silkscreened plates of Josef Albers' *Interaction of Color* made at Yale in 1963. The University of Delaware had a reserved copy in its library collection, and I spent hours studying its contents while wearing white gloves. For me, in addition to illuminating Albers' treatise on color behavior, it was a vital work of art. The logic of its presentation and the sheer lucidity of the printed plates were spellbinding. Albers' ideas about how colors influence each other made me question fundamental assumptions about visual perception and provoked reflection on the relationship between seeing and knowing. *Interaction of Color* demonstrates how the rewards of mindful observation are both visual and intellectual.

The rigor and focus of Albers' approach made a lasting impression on me and informed my own attitude to teaching color when, in the early 1980s at Skidmore College, I developed my first color curriculum for undergraduate art students. The foundational premise of that early color course, to bridge the gap between color theory and color practice, has remained central to my teaching throughout the decades of its evolution and refinement.

This third edition of *Color: A Workshop for Artists and Designers* is, like the first and second editions, based upon the color curriculum I developed in the 1990s at the Rhode Island School of Design. Its ongoing development is the product of nearly thirty years of teaching color to art students at RISD and Adelphi University and to adult artists in workshops around the country. The skill and understanding fostered by these studies are applicable to any visual art or design discipline; my students are graphic designers, illustrators, textile designers, textile fabricators, photographers, and painters. And, although color mixing is a key part of it, the course of study presented here requires no painting skill except for the ability to render flat colored swatches with a precision that increases naturally through practice. ("Building" color with simple, water-based paints makes innumerable tones available on demand and puts the student "inside" the color in ways not possible when working with manufactured or found color sources.)

This book presents a course of study that will help you master the fundamentals of color structure and behavior through a sequence of assignments that have been tested in the classroom. You will discover the significance of color's three structural attributes and learn to manipulate them independently through color mixing and their interrelationships. The assignments build on each other, reinforcing both conceptual and physical mastery. The portfolio of studies that you amass as you move through the course can be stored in book form and serve, along with the textbook itself, as a ready resource of color ideas and experiences. Your ultimate goal is the assimilation of color principles and concepts into an organic, personal relationship to color in your work.

Color: A Workshop for Artists and Designers has been used as a classroom text at universities and art schools, and by individuals, workshops, and small, self-directed groups. Its course of study is built around 17 separate assignments that involve the production of 32 discrete studies. In addition to handmade cut

and pasted paper studies, the book presents parallel assignments to be done digitally in Adobe Photoshop. A student can profit by pursuing either approach, or by doing some assignments by hand and others on the computer. Of course, the deepest experience, if circumstances allow, would be to make complete portfolios via both processes.

The assignments can be broken down into subgroups:

→ The introductory sequence of assignments 1–7 (Parts 4 and 5) is designed to help you understand the three attributes of color and their impact on color relationships. It introduces essential color terminology and will provide you with the technical skill required for more challenging assignments to follow.

→ In Assignments 8 and 9 (Part 6) you will focus upon staging color interactions based upon simultaneous contrast.

→ In Assignments 10, 11, and 12 (Part 7) you will experiment with intermixing strategies that guarantee unity throughout an array of tones.

→ Assignments 13 and 14 (Part 8) introduce tonal progression and the illusion of transparency to reinforce the contextual nature of color and refine your ability to effect subtle but critical color distinctions.

→ In Assignments 15 and 16 (Part 9) you will explore ways to summarize and employ color gleaned from outside sources.

→ Finally, Assignment 17 (Part 10) marries color to design to create contrasting moods.

This book is designed to be accessible as a treatise on color perception, structure, and behavior and as a course curriculum. The assignment instructions are visually separated from the main text and those for handmade and digital assignments are clearly differentiated. Many of the illustrations were created by students in recent classes and workshops and are placed to connect clearly to the text.

This third edition reflects improvements in the curriculum that I have been making over the past seven years. I have updated all but a handful of the illustrations and have rewritten much of the text to make it clearer and more accessible. Finally, I have introduced new assignments, adjusted others, and provided additional instructions for digital participation in most lessons. The result, I believe, is a useful and informative course of study aimed specifically at artists and designers who want to increase their ability to use color with skill and confidence.

—David Hornung

PART ONE SEEING COLOR

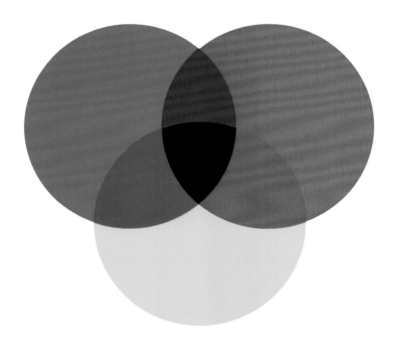

IN PART ONE YOU WILL

→ Recognize the basic mechanics of color perception.

→ Distinguish between additive and subtractive color theories.

→ Compare and contrast the RGB and CMY primary triads.

→ Discover how changing light conditions affect color.

Color is the place where our brain and the universe meet.
—Paul Klee

THE VISIBLE LIGHT SPECTRUM

The perception of color is a wonder of nature that we experience involuntarily whenever we open our eyes in a lighted place. To make it happen, our retinas are lined with light-sensitive cone-shaped receptor cells that communicate with the brain via the optic nerve. Our eyes are only sensitive to a narrow range of wavelengths within the entire electromagnetic spectrum. Wavelengths are measured in nanometers (precisely one billionth of a meter), and we can only sense wavelengths between approximately 380 and 750 nanometers in width. The range of colors that we can see is known as the *visible light spectrum*. Just outside the VLS lie infrared and ultraviolet radiation, which are invisible to the naked eye.

The SPECTRUM is made up of color zones. Each zone is a continuum that contains all of the variations of wavelength that we associate with a particular color. Yellow, for example, extends from a warm, golden yellow to the cooler yellow of a lemon skin. But the transitions between color zones are finely graded, so the exact point at which golden yellow slips into lemon yellow is impossible to determine (fig. 1.1).

The relative wavelengths of the colors of the spectrum are indicated in the table below:

HOW WE PERCEIVE COLOR

A lemon appears lemon yellow to us because its surface molecules reflect lightwaves that pulsate at approximately 570 nm. Lightwaves that are not reflected but absorbed do not stimulate our cone cells and are not perceived as color. Figure 1.2 illustrates the concept of the full spectrum of light striking a lemon. It shows all wavelengths except those that we perceive as lemon yellow being absorbed, while the yellow wavelength is reflected to the retina and relayed to the brain.

But seeing color is actually stranger and more wonderful than that. Figure 1.3 represents the mechanics of color perception more accurately. It indicates that lightwaves do not literally contain the color yellow, or any other color. Likewise, objects, e.g., a lemon, don't contain color, nor do inks, dyes, and other colorants. Color exists only in the brain. This illustration depicts uncolored lightwaves striking a lemon. One wavelength is selectively reflected back to the retina and passed on to the brain, which perceives the color yellow. (Yellow is perceived when the cone cells that trigger red and green are stimulated simultaneously; there are no individual yellow triggering cone cells.)

violet	blue	green	yellow	orange	red
380–450 nm	450–495 nm	495–570 nm	570–590 nm	590–620 nm	620–750 nm

1.1 The full range of the hue yellow extends from golden yellow (leaning toward orange) to lemon yellow (leaning toward green).

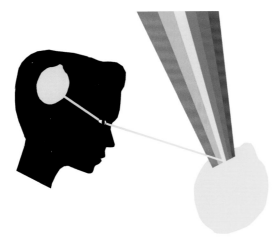

1.2 Color perception of a lemon.

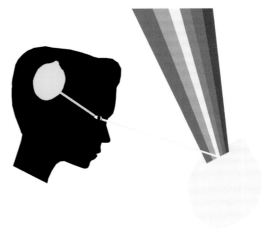

1.3 Another view of color perception: color exists in the brain.

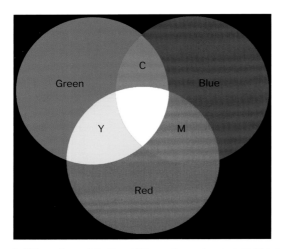

1.4 The primary triad in additive color: red, green, and blue.

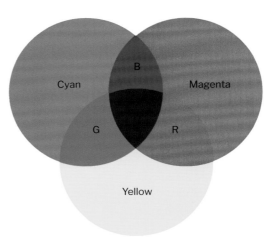

1.5 The primary triad in subtractive color: cyan, magenta, and yellow.

There are two distinct theories that apply to color perception: ADDITIVE, which explains color in light, and SUBTRACTIVE, which explains how color is seen when light is reflected.

Additive Color

Artists who work with lighting in interior design or in the theater rely on additive color theory. Instead of mixing pigments, they combine light. Light has three primary colors from which all other spectral colors can be achieved. They are red, green, and blue (RGB). These colors match the three kinds of cone cell that line the retina; each individual cone cell is specifically sensitive to wavelengths triggering red, green, or blue.

The combination of red and green light makes yellow, red and blue make magenta, and green and blue make cyan, so the secondary colors in additive theory are cyan, magenta, and yellow. Figure 1.4 represents the three primary and three secondary colors in light.

When you overlap two beams of colored light, the result is always brighter than both colors. Indeed, if you train red, green, and blue beams on a single spot, the result is white light. Combining colored lights creates brighter colors; therefore, light color theory is considered additive.

Subtractive Color

Subtractive color theory applies to color seen by means of reflected light. It has its own PRIMARY TRIAD: cyan, magenta, and yellow (CMY). Figure 1.5 represents the subtractive primary triad and its secondary colors: red, green, and blue.

In contrast to mixing colored light, mixing "pure" colors in pigment produces results that are darker and duller than the colors being combined. The less alike the colors being mixed, the darker the result. If you combine cyan, magenta, and yellow pigments the result will be a dark brown approaching black. (But not quite black, which is why black is added in four-color process printing.) Because mixing colored pigments subtracts luminosity, or the amount of reflected light, it is referred to as a subtractive process.

COLOR ON THE COMPUTER SCREEN

On the computer, color is lit from behind rather than reflected. Screen color appears cleaner and brighter than any printed output. Even if the hue, value, and saturation (terms examined later in this book) of a color are close, a printed version of a screen color can never truly match it. Anyone who creates images on the computer for printed output must contend with this color "translation."

There are several ways to work with color on the screen that are presented in Adobe Photoshop as color modes. You can choose a color mode when setting up a new document or by looking under "Image" to find "Mode" on an existing image. Some available color modes are RGB, CMYK, Duotone, Lab Color, and Grayscale. Among these, RGB and CMYK are appropriate to our study of color.

The RGB color mode corresponds to the primary triad in light (red, green, and blue). It is used in images intended for onscreen viewing, such as a PDF file or a website. All the colors in RGB are represented numerically on three channels. A particular green would appear on an RGB color slider as R92, G141, and B107 (see fig. 1.6). On the CMYK slider, the same green would be represented numerically as C63, M21, Y63, and K16 (fig. 1.7). As the RGB mode uses three color channels attributed to the three colors of light, the CMYK mode uses four color channels (cyan, magenta, yellow, and black). These are the colored inks used in four-color printing. CMYK is the appropriate mode for images that will appear in a printed format.

THE EFFECT OF LIGHT ON COLOR PERCEPTION

Our discussion of reflected light has been based on the visible light spectrum you would experience in sunlight seen around noon on a cloudless day. But the character of sunlight at any given moment is determined by the time of day and atmospheric conditions. Light in the morning or late afternoon filters out particular colors. Other factors, such as heavy cloud cover or air pollution, can also limit the range of available lightwaves. In contrast to that of midday, late afternoon sunlight seems to cast a red-orange glow that enriches warm colors and dulls cool ones.

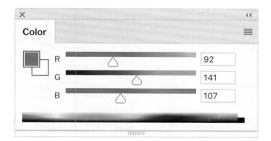

1.6 The composition of a green color seen in the RGB color mode in Adobe Photoshop.

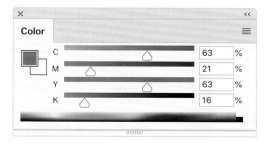

1.7 The composition of the same green seen in the CMYK color mode in Adobe Photoshop.

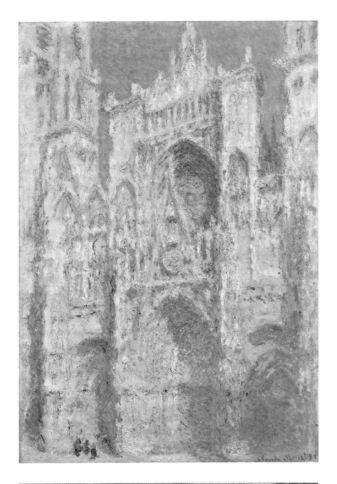

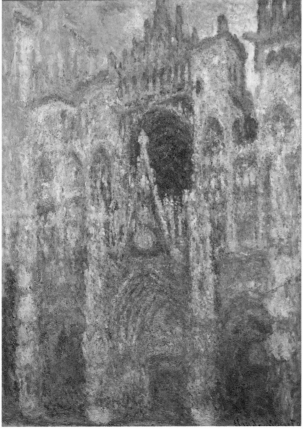

Monet's Experiments

In the late winters of 1892 and 1893, Claude Monet painted over 30 pictures of Rouen Cathedral. Two of them are reproduced here (figs 1.8 and 1.9). This series of paintings, along with several similar experiments with other subjects, including a field of haystacks, poplars, and the Houses of Parliament in London, was Monet's attempt to paint the effect that changing light and atmospheric conditions have upon the color of an object or a scene.

Monet's studies of Rouen Cathedral address its architectural façade from nearly the same vantage point each time. By maintaining a consistent point of view from picture to picture, he clarified his intent. Through this somewhat scientific approach Monet elevated his curiosity about the effects of light to a fitting subject for serious works of art.

1.8 Claude Monet, *Rouen Cathedral. West Façade, Sunlight*, 1894, oil on canvas. Chester Dale Collection, National Gallery of Art, Washington, DC.

1.9 Claude Monet, *Rouen Cathedral, the West Portal and the Tour d'Albane, Harmony in Blue*, 1894, oil on canvas. Musée d'Orsay, Paris.

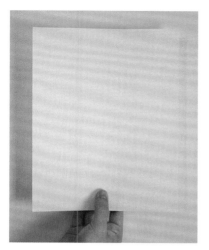 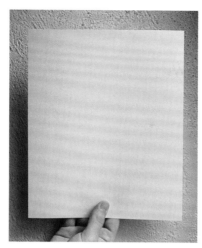

1.10A–C A sheet of white paper under: A. daylight, B. fluorescent, and C. incandescent.

Artificial Light

Artificial light is sometimes called reduced-spectrum lighting because it is deficient in some of the color frequencies found in sunlight. Incandescent bulbs, for example, yield a warm light that favors the yellow, orange, and red frequencies. This is the familiar warm light of a typical reading lamp.

Fluorescent lighting, on the other hand, produces cooler frequencies and casts an illumination that enlivens blues and greens. Warm colors appear duller under this cool light.

For a clear demonstration of the hue bias of various light sources, carry a piece of white paper from a daylit window, to a fluorescent light, and then to an incandescent lamp. Pay attention to the shifting color of the page as you move from one light source to another (as illustrated in figure 1.10A, B, and C).

When making color studies, try to work under lighting that is neither too cool nor too warm. Evaluate your work under the same lighting conditions in which you made them.

COLOR CONSTANCY

Color perception is sometimes influenced by a psychological tendency to see what we expect to see.

The perception of anticipated rather than observed color is called "color constancy." Color constancy has long been acknowledged. In the early nineteenth century the English scientist Thomas Young noticed that "when a room is illuminated by the yellow light of a candle, or by the red light of a fire, a sheet of writing paper still appears to retain its whiteness."

A bright yellow tennis ball seen in deep shadow, for example, will appear yellow even though its true color in that setting is a dull, dark, yellowish gray. Learning to paint from life, students struggle to read color accurately and set aside their automatic assumptions. It takes a surprising amount of effort to actually see a color stripped of preconception.

For a more detailed explanation of the science behind color perception, follow these links:

→ https://www.pantone.com/color-intelligence/articles/technical/how-do-we-see-color

→ https://www.aao.org/eye-health/tips-prevention/how-humans-see-in-color

And, for added information about the way light affects color:

→ https://www.xrite.com/blog/color-perception-part-1

(Note: If the links stop being accessible, you can also visit archived versions here: https://archive.org/web/)

FIRST PRINCIPLES

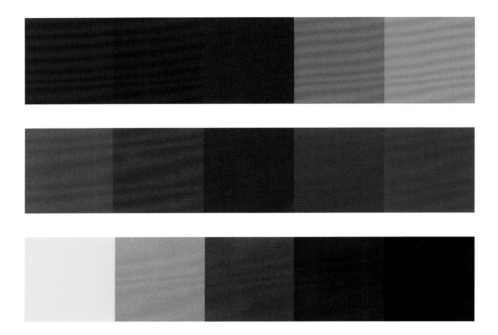

IN PART TWO YOU WILL

→ Recognize fundamental color terminology.

→ Memorize the three attributes of color.

→ Compare the RYB and CMY color wheels.

→ Separate saturation into three distinct levels.

→ Discover how color temperature relates to hue.

If one says "red" – the name of a color – and there are fifty people listening, it can be expected that there will be fifty reds in their minds. And one can be sure that all these reds will be very different. —Josef Albers

THE STRUCTURE OF COLOR

Most people are aware that colors have more than one visible quality. This is apparent because color names, such as "red," are frequently coupled with adjectives. Expressions such a "fiery red," "cherry red," or "blood red" reflect the fact that colors have characteristics not adequately represented by a simple color name.

In fact, all colors possess three distinct attributes that account for their appearance. Each can be manipulated independently, either by color mixing or by altering the context in which the color appears. These attributes are HUE, VALUE, and SATURATION.

2.1 The hue continuum organized as a circle.

HUE

When we refer to a color on the spectrum by its name, we talk about its hue. The spectrum is a HUE CONTINUUM that stretches from infrared to ultraviolet and passes through recognizable color zones. Theoretically, at the heart of every color zone is the pure, true version of each hue. But because each zone contains an infinite number of variations, there can be no determinate center to any hue zone.

Most of us carry a mental picture of individual hue identities, especially for simple colors such as red and blue. But this conception is personal. A true, essential blue would lie somewhere between cyan (a blue that leans toward green) and ultramarine (which is biased toward violet). But its precise position is impossible to determine. Figure 2.1 illustrates the hue continuum.

The Primary Triad

The primary triad is a fundamental color concept that, in addition to being useful, has an almost mythic allure. In theory, by intermixing two or three of the colors of the true primary triad any color can be achieved, while the primary colors themselves are unobtainable through mixing.

As children, we are taught that the primary hues are red, yellow, and blue. But strictly speaking, red and blue are not primary colors because red can be made by combining magenta and yellow and blue can be made by combining magenta and cyan. The correct primary triad has, since the late nineteenth century, been determined to be cyan, magenta, and yellow. These three colors are truly singular and incapable of being mixed from others. They also combine to make the broadest range of visible tones. That is why cyan, magenta, and yellow (plus black) are the basis of four-color printing.

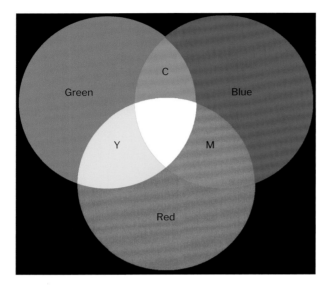

2.2 The additive (light) and subtractive (pigment) primary triads.

(In printing, various combinations and densities of translucent ink in cyan, magenta, yellow, or black are superimposed to generate countless tones. The amount of white paper showing through the ink controls lightness; there is no white ink. Color mixing in printing is therefore a layering process, while painting with opaque pigments mingles colors to create new tones.)

The diagrams in figure 2.2 show the additive (light) and subtractive (pigment) primary colors. When pairs of primaries are combined they make secondary colors. Notice that the secondary colors of the light primaries (RGB) are cyan, magenta, and yellow. Also note that the secondary colors of the pigment primaries (CMY) are red, blue, and green.

Color Temperature

Colors can be classified by temperature, either "cool" or "warm." While temperature is an important aspect of color, it is not an independent structural attribute as are hue, value, and saturation. Temperature is an aspect of hue. Cool colors run approximately from green to blue-violet (fig. 2.3) and warm colors extend from yellow-green to red-violet (fig. 2.4). Colors on the boundaries of these ranges can seem more ambiguous in temperature than those like blue and orange, which lie near the center.

The appearance of temperature, like all aspects of color, is contingent upon neighboring colors. Yellow-green, for example, can look warm when seen against violet but cooler when placed against yellow-orange, as shown in figure 2.5.

2.3 Cool hues.

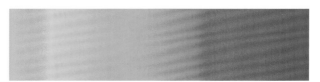

2.4 Warm hues.

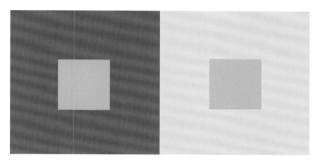

2.5 Color temperature can be influenced by a neighboring color.

Even within a single hue we can perceive a shift in temperature. Yellow, for example, is considered warm when viewed against the entire color spectrum. But within the yellow zone, as it moves away from orange and toward green, its temperature seems to cool. Hence, light yellow appears cooler than deep yellow. Likewise, scarlet or flame red is warmer than crimson. Blues are more evasive. Although a temperature shift from cyan to ultramarine is clear, which blue is cool and which is warm might seem ambiguous. Ultramarine is biased in the direction of violet and cyan toward green. Violet being cooler than green suggests that ultramarine should be regarded as the cooler blue.

VALUE

Value refers to the LUMINOSITY or the relative lightness or darkness of a color. It is determined by the amount of light a color reflects regardless of hue. In *Colour: A Textbook of Modern Chromatics* (published in 1904), Ogden Rood explains that the more light a color reflects, the more luminous it is. Of the pure colors, yellow is the most luminous and violet the least. A pure white object would have the greatest luminosity while a densely black object, such as black velvet, would have almost none.

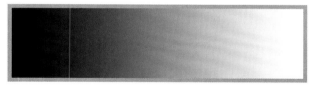

2.6 The value continuum.

As with the hue continuum, the VALUE CONTINUUM contains infinite variations (fig. 2.6). The full range of values is often simplified into a progressive series of tones called a GRAYSCALE. The grayscale shown in figure 2.7 consists of 11 steps ranging from black to white in even increments. (The term "grayscale" is also used by Adobe in Photoshop to refer to its black-and-white color mode.)

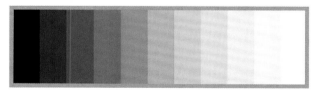

2.7 An 11-step grayscale.

In figure 2.8 a grid of colors is rendered in grays, eliminating hue but maintaining value relationships.

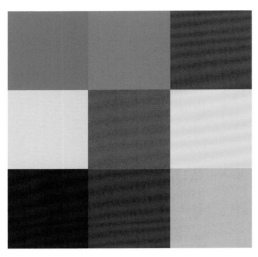

2.8 A grayscale rendering of a block of colors.

2.9 The lighter color is less saturated.

2.10 The lighter color is more saturated.

SATURATION

The relative purity of a color is known as saturation. The more a color resembles the clear, fully illuminated colors seen in a prism or rainbow, the more saturated it is said to be. At first it may be difficult to distinguish saturation from value. But in fact, the two qualities are completely independent of each other. For example, in figure 2.9 the square that is lighter in value (a pale yellow) is less saturated than its green neighbor. In figure 2.10 the opposite is true: the lighter square (still yellow) is also the more saturated of the two.

A SATURATION CONTINUUM can be created by intermixing two fully saturated COMPLEMENTARY HUES, e.g., blue and orange. Figure 2.11 illustrates the blending of pure orange and pure blue. The tones in between the two poles become gradually less saturated as they approach the midpoint of the intermixture. At the precise middle of the scale is a neutral tone that favors neither orange nor blue.

As with the hue and value continua, the saturation continuum is too vague to be useful in envisioning saturation. To make it easier to visualize, we break down saturation into three distinct levels: PRISMATIC COLOR, MUTED COLOR, and CHROMATIC GRAYS.

Prismatic Color

Prismatic colors are as pure in saturation as is possible with pigments. Colors such as cobalt blue, cadmium yellow, and cadmium red are prismatic when they come out of the tube. The value of a prismatic color is always linked to its hue identity. Therefore, prismatic yellows are always light and prismatic violets are always relatively dark. Moreover, this level of saturation is absolute; a color cannot be prismatic to a degree. Traditional primary and secondary hues (red, yellow, blue, green, orange, and violet) are shown fully saturated in figure 2.12. (The traditional primary triad, while not scientifically accurate, has a place in color practice that will be explained later in this chapter.)

Muted Color

Muted colors have a range that extends from slightly dulled prismatic colors to the soft but rich tones that merge into chromatic gray. Figure 2.13 shows primary and secondary hues as muted colors.

Chromatic Gray

More subtle than muted colors, chromatic grays (shown in figure 2.14) have a broader potential range of value that can extend from very dark to almost white in most hues. The dullest chromatic grays are sometimes called "neutral colors," colors that have a faintly perceptible hue. The term "chromatic" means "having color," so chromatic grays are grays and browns that have a perceptible hue identity. What are commonly called "grays" are chromatic grays that subtly hint at the cool colors of the spectrum: blue, green, and violet. Warm chromatic grays, with hints of red, orange, or yellow, are commonly called "browns."

Achromatic Gray

Colors all have hue, value, and saturation. While white and black have value, they lack hue and saturation. Therefore they, and grays made from them, are "achromatic" or "without color." In figure 2.15 six ACHROMATIC GRAYS match the values of the previous illustrations.

(In truth, pure, achromatic black would be as black as darkness and pure white as white as light itself. However, given the impurity of pigments and the coloristic influence of lighting, black and white paint can never be pure or truly achromatic. Lead whites are considered warm and zinc whites cold; i.e., they have either a very faint brown or blue-gray cast in daylight. Black pigments are also varied in temperature: jet black is a cool blue-black and ivory black is a warm, slightly brown-black. But despite the extremely subtle presence of temperature (hue) in black and white pigments, we still use the term "achromatic" to recognize how black, white, and their intermixed grays, function differently in intermixture than all other colors.)

Figure 2.16 shows the three levels of saturation in relation to the saturation continuum. (Bear in mind that, while prismatic color becomes muted color as soon as it loses the appearance of purity, the transition from muted color to chromatic gray is more gradual than the diagram allows.)

The distinction between muted color and chromatic gray is an important one. In the color workshop, the first studies address the location of that boundary. After a brief period of practice and discussion, the border between the two categories becomes clearer. As with relative qualities in other art forms, e.g., the difference between *piano* and *pianissimo* (quiet and very quiet) in music, the ambiguity of the transition between muted color and chromatic gray in no way compromises the meaning or practicality of the terms.

2.11 A saturation continuum from orange to blue.

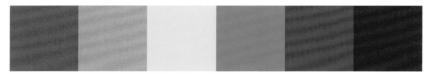

2.12 Fully saturated prismatic colors.

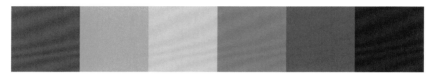

2.13 Muted colors.

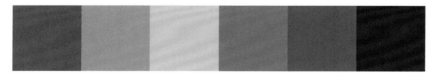

2.14 Chromatic grays.

2.15 Six achromatic grays that match the values in 2.12–14.

2.16 The three levels of saturation on a blue-orange continuum.

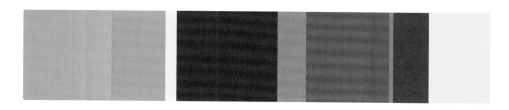

2.17 Ten colors that show a broad range of hue, value, and saturation.

2.18 The same hues from figure 2.17 with a narrow value range.

COLOR RANGE

Any group of colors can be assessed in terms of the range of its hue, value, and saturation. When doing so we apply the terms "broad," "moderate," or "narrow." For example, the strip of ten colors in figure 2.17 has a broad hue range because it includes all six primary and secondary hues. Its value range is also broad, in that it spans almost the entire value scale from dark to light. The saturation range is likewise broad because we see prismatic colors, muted colors, and chromatic grays.

Contrast figure 2.17 with figure 2.18. They share identical hues, and the saturation range in both is broad. But in 2.18 the value range is extremely narrow: all the colors are located in the middle of the grayscale. Notice how a dramatic shift in only one attribute (value contrast) significantly alters the character of this color group.

As you will discover in the color workshop, hue, value, and saturation can be manipulated together or independently through color mixing or by altering color context.

COLOR WHEELS

Color theorists since the early eighteenth century have found it useful to organize the color spectrum in a circular configuration or COLOR WHEEL. The color wheel provides a mental map of hue distribution that the artist or designer can call up while imagining color relationships in the abstract. But, ideas about how essential hues should be arranged vary. As we have seen, the visible color spectrum is a continuum with discernible zones, but no clearly marked divisions. Therefore, any attempt to map out hue relationships in discrete steps is only as correct as it can be practically applied. The two wheels most commonly used today are based on the two triads: red, yellow, and blue (RYB) and cyan, magenta, and yellow (CMY), as shown in figures 2.19 and 2.20.

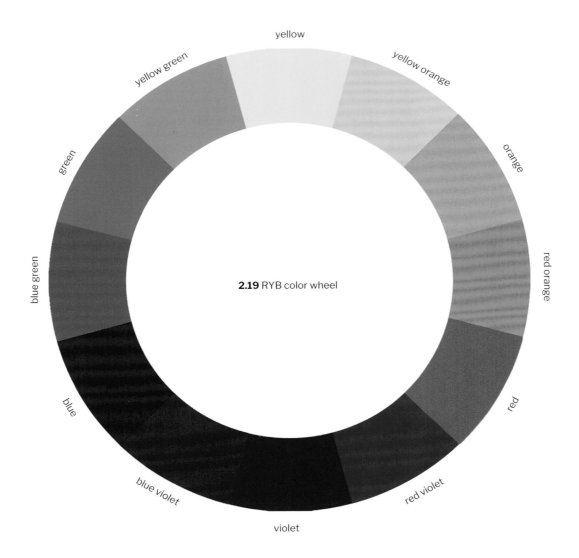

yellow

yellow green

yellow orange

green

orange

blue green

red orange

2.19 RYB color wheel

blue

red

blue violet

red violet

violet

The RYB Color Wheel

In the RYB wheel, the primary triad is red, yellow, and blue and the SECONDARY TRIAD is green, orange, and violet. Throughout this wheel, the color names are all simple and universal, with some minor disagreement about the terms "violet" and "purple." The names of the TERTIARY COLORS combine those of the primary and secondary hues that comprise them, with the primary color usually listed first. "Red-orange," "yellow-green," and "blue-violet" not only identify those hues, they locate them precisely on the wheel and, hence, in the artist's mind. The RYB wheel is easy to memorize and envision. The intervals between the colors are consistent: secondary colors are visibly centered between two primaries and tertiary colors are all located midway between a primary and a secondary. The complementary pairs everywhere on the wheel interact in the same way: they energize each other when placed as neighbors and temper each other when they are intermixed. When any two complements are mixed together, the result gradually gets duller and darker as the strength of the two colors becomes more equal, as shown in figure 2.21.

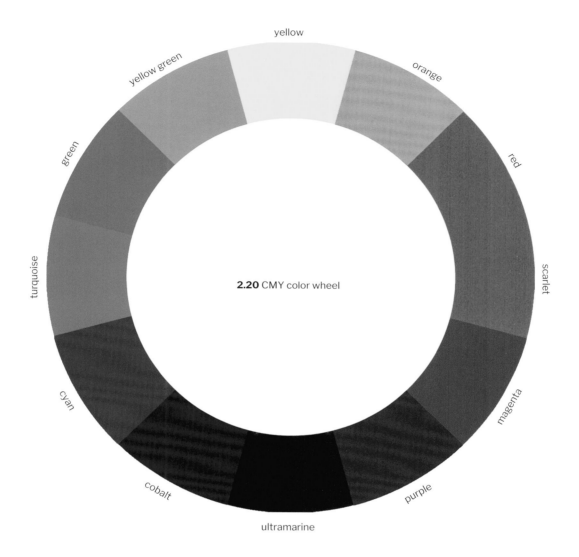

yellow

orange

yellow green

green

red

turquoise

2.20 CMY color wheel

scarlet

cyan

magenta

cobalt

purple

ultramarine

The CMY Color Wheel

In comparison, the CMY wheel suffers uneven spacing. The distances from cyan to ultramarine and magenta to red take up six places on a twelve-part diagram when, on the RYB wheel, they are contained roughly within two. This makes it necessary to put yellow next to orange, a rather large jump for two neighboring hues, especially when the same distance is accorded to cobalt and ultramarine blue at the bottom of the same wheel.

CMY wheels are also less uniform in nomenclature from wheel to wheel. For example, the color between magenta and red in figure 2.20 is identified as "scarlet." On another wheel the same tertiary color is called "rose." The color adjacent to cyan ("turquoise" on the CMY wheel shown here) is elsewhere "green cyan" and, in another version, "spring green."

Finally, the relationship of complementary pairs (colors that lie directly opposite each other on the wheel) should facilitate predictive color mixing. As previously mentioned, in the RYB model mixing complementary pairs (always a primary and a secondary color) produces a dull, dark neutral tone.

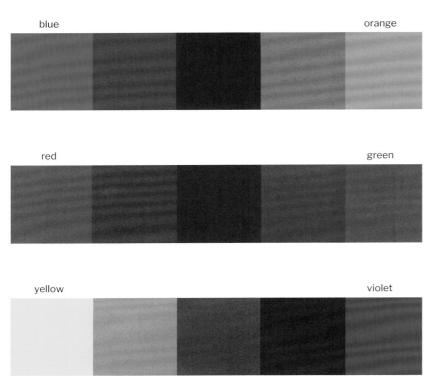

2.21 Intermixed RYB complementary pairs.

2.22 Intermixed CMY complementary pairs.

In the CMY model, however, complementary pairs behave erratically when intermixed. When you combine the CMY complements magenta and green or cyan and red, they yield increasingly duller and darker versions of the two polar colors until you arrive at a dark gray at the center, similar to intermixed complements with RYB. However, mixing blue with yellow, another CMY complementary pair, just produces a series of greens as in figure 2.22, where the middle tone can never be duller than a muted color.

The color wheel is a conceptual construct that must balance science with utility. It is simply a way to organize thoughts about color relationships and predict the behavior of colors when seen together or intermixed. In this workshop, we'll be working with the less scientifically accurate but, for our purposes, more practical RYB primary triad model.

The HVS Color Wheel

Figure 2.23 shows an RYB color wheel that is organized by hue, value, and saturation. Primary, secondary, and tertiary hues are arranged around the circle in even, pie-slice sections. The three levels of saturation are arranged in concentric circles with prismatic colors closest to the center, followed by muted colors and chromatic grays. The outer ring is composed of achromatic grays that match, in value, the tones they abut. Values are consistent throughout each hue section.

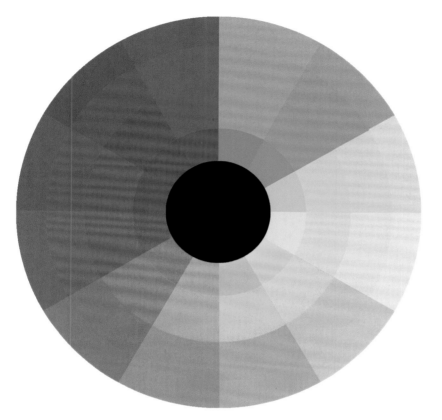

2.23 The HVS color wheel.

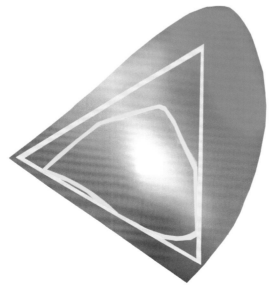

2.24 Color gamuts of the visible spectrum, RGB, and CMYK.

COLOR ON THE COMPUTER SCREEN

Any range of observable color is called a GAMUT. Colors on a computer monitor are more limited in number than those in the visible spectrum.

Figure 2.24 shows the range of three color gamuts. The full visible spectrum that we can experience in bright sunlight is, of course, the largest gamut. In comparison, all other forms of lighting, including that of a computer monitor are less inclusive. The second largest, outlined with a pink triangle, is the RGB gamut. The smallest area, bound by a yellow line, is the CMYK gamut. Because the RGB gamut exceeds that of CMYK, there are colors that can appear on the computer monitor that will not be reproducible in printed form. (Adobe programs give a warning sign – ! – when a color created in RGB mode falls outside the CMYK gamut.)

In digital output, i.e., four-color and inkjet printing, cyan, magenta, and yellow (plus black) are overlapped and juxtaposed in tiny fragments (pixels) for the eye to mix into what appear to be continuous tones. Colors appear more vivid on a monitor than they do in print, but subtle color nuances are more readable when reflected from the surface of a print or painting than they are on the computer screen.

PART THREE THE COLOR WORKSHOP

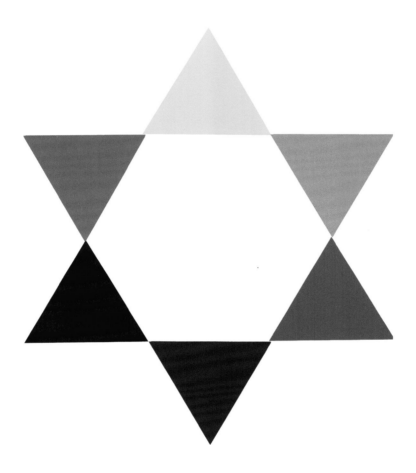

IN PART THREE YOU WILL

→ Identify the overall goals and procedures involved in this course of study.

→ Obtain a specific list of materials needed for the course.

→ Prepare for the technical demands of the upcoming assignments.

Color is so much a matter of direct and immediate perception that any discussion of theory needs to be accompanied by experiments with the colors themselves.—Walter Sargent

ABOUT THE WORKSHOP

This book is an actual course of study, a "workshop" approach to understanding color principles as they are applied in illustration, textile design, graphic design, animation, fine art, and painting. It presents a series of color exercises that will give you a confidence with color that you can bring into your studio practice. Every study you make will be small and mounted on either A4 or US letter-size white card stock. As your studies accumulate, you will assemble them into a portfolio in book form. The portfolio/book is a repository of your work, a document of your progress, and a reference that you will find useful to own.

The techniques you will be using are simple: painting color swatches and mounting them into small studies that illustrate specific color principles. The technical skill required is minimal, so no matter your level of skill and experience, you will be able to participate fully.

Making Color Studies

Unlike many color courses that use color found in magazines or packaged color samples, this approach relies upon "building" color through color mixing. Precise color mixing offers both a greater range of tones and more control than found color can provide. Even more important is the benefit of bringing thought and action together every time you mix a color on the palette. Color mixing brings you "inside" the color. This makes concepts more tangible and will help you make the leap from theory to practice.

Some find the prospect of color mixing a little daunting – especially those who have little or no painting experience. But this is not a painting course and needs only modest hand skill. Work within your ability to engage the requirements of each lesson; faulty craft is only a problem when it obscures the intent of a study. With a little care, that can easily be avoided, and your work will improve as you move through the lessons.

PAINT

The color principles we will explore are applicable to any painting medium, but the best paints for color studies are fast-drying, water-based paints that dry to a matte finish. Quick drying speed allows for almost instant correction and the matte surface provides a clear view of the color from any angle.

Gouache

Before computers, design industries favored a water-based paint called "gouache." Gouache can be used somewhat like watercolor, but it can also be extremely opaque and produce lucid, flat tones in any color. Because it dries to a matte surface, gouache is easy to read and photograph.

Acrylic Gouache

Conventional acrylic paint is usually too translucent to be ideal for color studies, but several manufacturers offer a hybrid paint that combines the best qualities of gouache and acrylic. Sold as "acrylic gouache," it has one great advantage over traditional gouache: when dry, it can't be reactivated either by scrubbing or overpainting. Covering a dried layer with new paint is a fresh start, so any number of corrections and cover-ups are easy to make. Acrylic gouache dries in 20 minutes or less in most climates.

WORKSHOP MATERIALS

In addition to paint, these are the materials you will need to make your color studies:

1. Card stock: sold in packages of 250 sheets at most stationery outlets. It comes letter-size (11 x 8 ½ inches or 27.9 x 21.6 cm). This smooth, 110 lb. (298 gsm) white card is heavy enough to paint on and also makes a sturdy support for glued elements. A more expensive alternative is two-ply vellum Bristol Board.

2. Thin paper for collage color swatches: we recommend the Bienfang "Graphics 360" tablet. This 100 percent rag paper is thin, strong, and perfect for very flat presentation when glued down. A less costly but workable alternative is common newsprint.

3. Water container and paper towels.

4. Brush: a 1 inch (2.5 cm) or ¾ inch (1.9 cm) flat aquarelle brush with a beveled clear handle for burnishing.

5. Plastic palette knife.

6. Glue stick.

7. Scissors and a #1 or #2 X-acto knife.

8. Pencil.

9. Ruler.

10. Roll of Scotch brand removable magic tape for masking (3M item #811).

11. Palette: If using traditional gouache, you need a plastic cup palette. The most useful have six or more wells and a flat area for color mixing. If using acrylic gouache, a paper palette pad serves well.

12. Portfolio book to contain both finished work and work in progress. The best option we have found is the Itoya Profolio. At 11 x 8 ½ inches (27.9 x 21.6 cm) with 24 pages (48 sides), these books not only store work, but can also hold color swatches for subsequent use in color studies.

There are four brands, in particular, that have the colors you will need. These are: Turner Acryl Gouache, Holbein Acryla Gouache, Liquitex Professional Acrylic Gouache, and Chroma's Jo Sonja Flow Acrylics (a less expensive but still very good, matte acrylic paint).

Co-primary Colors

As described in Part Two, we use an RYB primary triad. But the traditional "centered" red, yellow, and blue triad has a built-in limitation in color mixing. As you can see in figure 3.1, the secondary colors obtainable from red, yellow, and blue are not the prismatic spectral hues you would expect, but duller, muted versions. To compensate for that, we use six colors that we call CO-PRIMARIES, i.e., a warm and cool version of red, yellow, and blue.

This refinement of the primary triad makes it possible to achieve more vivid secondary colors. It also promotes an awareness of hue bias that is an important aspect of all color mixing, particularly useful to painters and illustrators. Later studies in this course explore the way hue bias affects the overall quality of light in a limited palette.

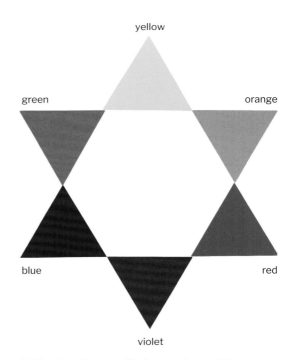

3.1 The three "centered" primary colors and the secondaries that they produce when intermixed.

COOL RED

Turner: Alizarin Hue
Holbein: Carmine
Liquitex: Cad Free Red Deep
Jo Sonja: Permanent Alizarin

Winsor & Newton: Alizarin Crimson

WARM RED

Turner: Cad Red Light Hue
Holbein: Scarlet
Liquitex: Cad Free Red Light
Jo Sonja: Napthol Red Light

Winsor & Newton: Cad Scarlet

WHITE

Turner: White
Holbein: Titanium White
Liquitex: White
Jo Sonja: Titanium White

Winsor & Newton: Permanent White

COOL YELLOW

Turner: Cad Yellow Light Hue
Holbein: Primary Yellow
Liquitex: Cad Free Yellow Light
Jo Sonja: Yellow Light

Winsor & Newton: Lemon Yellow

WARM YELLOW

Turner: Permanent Yellow Deep
Holbein: Deep Yellow
Liquitex: Cad Free Yellow Deep
Jo Sonja: Yellow Deep

Winsor & Newton: Permanent Yellow Deep

The colors you will need include six co-primaries, a brown EARTH TONE (burnt umber), Payne's gray, a red earth tone (burnt sienna), a yellow earth tone (yellow ocher or oxide), and white. Figure 3.2 shows these colors in a variety of brands.

Notes on the available quantities per brand:

COOL BLUE

Turner: Ultramarine Blue
Holbein: Ultramarine Deep
Liquitex: Ultramarine Blue Red Shade
Jo Sonja: Ultramarine Blue Deep

Winsor & Newton: Ultramarine

WARM BLUE

Turner: Phthalo Blue
Holbein: Primary Cyan
Liquitex: Phthalo Blue Green Shade
Jo Sonja: Phthalo Blue

Winsor & Newton: Phthalo Blue

→ *Turner Acryl Gouache: 20 and 40 ml tubes.*

→ *Holbein Acryla Gouache: 20 ml tubes.*

→ *Liquitex Acrylic Gouache: 59 ml tubes.*

→ *Chroma's Jo Sonja Flow Acrylic: 74 ml tubes.*

WARM CHROMATIC DARK

Turner: Burnt Umber
Holbein: Burnt Umber
Liquitex: Burnt Umber
Jo Sonja: Burnt Umber

Winsor & Newton: Burnt Umber

COOL CHROMATIC DARK

Turner: Japanesque gray
Holbein: Burnt Umber+Ultramarine
Liquitex: Burnt Umber+Ultramarine
Jo Sonja: Payne's gray

Winsor & Newton: Burnt Umber + Ultramarine

→ *Winsor & Newton Traditional Gouache: 14 ml tubes (traditional gouache goes much further than acrylic gouache, 14 ml tubes are roughly equivalent to 59 ml tubes in acrylic gouache).*

You will need at least 40 ml of paint in each color with double that amount of white.

YELLOW EARTH TONE

Turner: Yellow Ochre
Holbein: Yellow Ochre
Liquitex: Yellow Oxide
Jo Sonja: Yellow Oxide

Winsor & Newton: Yellow Ochre

RED EARTH TONE

Turner: Burnt Sienna
Holbein: Burnt Sienna
Liquitex: Burnt Sienna
Jo Sonja: Burnt Sienna

Winsor & Newton: Burnt Sienna

Paint brands can be intermingled.

3.2 Paint chart showing colors needed for the course in several brands.

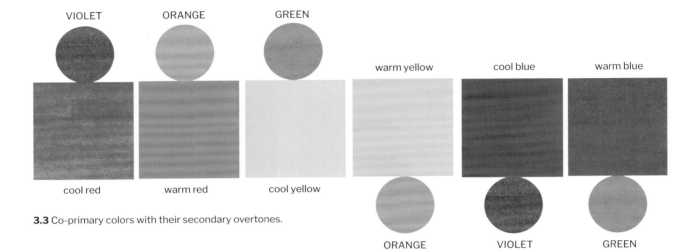

3.3 Co-primary colors with their secondary overtones.

The Co-primaries and Their Overtones

Each of the six co-primary colors in our primary triad has a hue bias or OVERTONE that implies a specific secondary hue. Figure 3.3 shows each co-primary and its overtone. When mixing prismatic secondaries, use the co-primary pair whose overtone matches the goal. For example, for a prismatic green, use the co-primary versions of blue and yellow that have a green overtone.

Tips for Painting Swatches

All the studies in this course will be relatively small. Typical proportions are 5 x 7 or 6 x 6 inches (12.7 x 17.7 or 15.2 x 15.2 cm), small enough to be mounted on an A4 or US letter-sized sheet of card stock. These small dimensions make it possible to create many studies in a short time and the uniform size of each sheet fits easily into the portfolio/book.

Most studies begin with color swatches painted on a thin, strong paper. The best choice is an acid free "marker" paper and there are several good brands available. It should be very thin, tear-resistant and take paint well, so when colored swatches are glued down, it looks as if the cut shapes are painted directly on the card stock.

Because the studies are small, color swatches will seldom need to be larger than 5 x 5 inches (12.7 x 12.7 cm). Figure 3.4 shows swatches painted on marker paper with an X-acto knife included for scale.

Any wet paint left over on the palette should be brushed out as swatches on marker paper and saved for later use. At the end of a work session, press your pages of swatches under a heavy book for a while before cutting them apart. (Never cut before pressing: separated unflattened swatches tend to roll up and become difficult to work with.) Save flattened swatches in the back pages of your portfolio book until you are ready to use them.

3.4 A page of swatches painted on marker paper.

1. Applying removable tape to pencil line.

2. Painting background.

3. Removing tape.

4. Finished background on card stock.

3.5 Painting a background color on card stock.

Gluing Swatches to Card Stock

Use a glue stick to adhere color shapes to the card stock support and burnish them down with the beveled handle of a brush, a credit card, or any other good burnishing tool. When burnishing, protect the paint surface by placing a sheet of thin paper over it. Press down and rub on the paper mask rather than directly on the paint surface.

Painting a Background Color

Many of the studies will begin with a colored background painted directly on card stock using removable tape to establish the boundaries of the square or rectangle. The painted background will serve as a color in the finished study and immediately eliminates the white of the page. See figure 3.5 for steps in masking and painting a background.

It's a good idea to make several templates from card stock, each with a different size "window," before beginning your studies. When you need a centered rectangle or square for a study, simply use the template to draw a light pencil line establishing the perimeter of your design, as in figure 3.6.

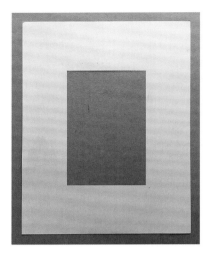

3.6 A window mat for outlining formats on card stock.

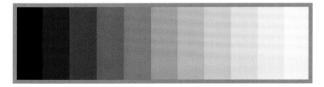

3.7 An 11-step grayscale made in Adobe Photoshop.

Making a Grayscale

Before beginning you will need an accurate grayscale to aid in color mixing and selection. It should be achromatic (having no hue bias) and consist of 11 even steps from extremely dark to white (fig. 3.7). A grayscale is easy to make in Adobe Photoshop using "Grayscale" mode. Print it on Epson heavyweight matte presentation paper or, if using a thinner matte printing paper, glue it to card stock for support.

Another option is to purchase a grayscale "value finder." These are available in art supply shops and through online distributors. Unfortunately, commercial grayscales typically have ten steps and thus lack a mid-tone. But they are still useful. A good grayscale is an essential tool that you will need throughout this course of study.

The third option is to paint a gray scale. Create an achromatic or temperature-neutral dark by mixing Payne's gray and burnt umber. That will be your darkest extreme. Then add increments of white to create 11 evenly spaced transitional tones up to pure white. Paint all tones on marker paper and, when you have all 11 even steps from dark to white, cut the strips out and mount them on card stock with no white spaces in between. Then cut your gray scale out of the page for use. (Part Four offers tips on painting swatches on marker paper.)

COLOR STUDIES ON THE COMPUTER

Although the course features handmade studies, making a parallel group of studies on the computer can greatly enhance your understanding. Most of the painted paper assignments in this course will be accompanied by a digital version. You might even choose to do only the digital assignments. Careful reading coupled with digital exploration alone is a good choice for those whose studio work is entirely computer-based. For all others, I recommend handmade or a combination of both handmade and computer studies.

Adobe Photoshop and Illustrator are both excellent programs for digital color studies. But since Photoshop skills are more common, assignments will be presented in that application. When doing studies on a computer it is very important that you "build" all color on the sliders (not merely select from a palette display) and that shortcuts using filters are avoided altogether. Essentially, all studies should be made by creating shapes and filling them in with color one by one.

THE ILLUSTRATED GLOSSARY

At the end of this book is an illustrated glossary that contains all the color terms you will encounter as you work your way through these studies. An occasional visit to the glossary can be a convenient memory aid throughout the course.

THREE DIAGRAMS THAT AID COLOR CONCEPTION

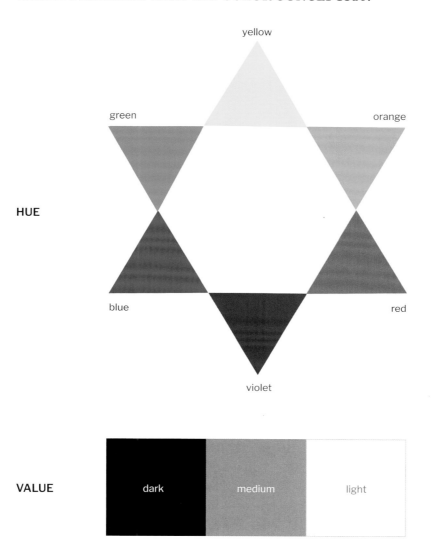

HUE

VALUE

SATURATION

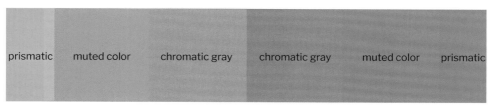

3.8 As you begin working on color studies, try to keep these diagrams of the three attributes of color in mind.

PART FOUR BEGINNING COLOR STUDIES

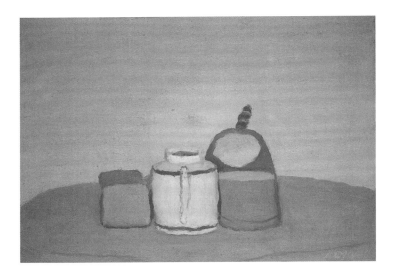

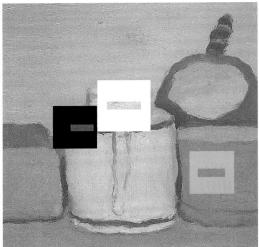

IN PART FOUR YOU WILL

→ Discover the effect of hue overtones on color mixing.

→ Apply color terminology to physical practice.

→ Show how intermixing colors can alter their attributes.

→ Arrange color according to predetermined specifications.

It has been suggested that Rembrandt created the complex, dark, chocolaty shadows in his paintings simply by scraping together whatever happened to remain on his palette and blending that directly onto the canvas, because so many different pigments have been found within their depths.—Kassia St. Clair, *The Secret Lives of Color*

CHROMATIC DARKS

We do not include black among the colors you will be using for this course. Instead, we use CHROMATIC DARKS to mix with other colors for darkening or dulling, or as colors themselves. When you perceive the warm or cool bias in a chromatic dark, no matter how subtle it may be, you are perceiving its temperature and therefore its hue content. *As a general rule when using chromatic darks, mix cool dark with cool colors (blues, violets, and greens) and warm dark with warm colors (oranges, reds, and yellows) to create tones that will maintain hue identity. This is especially true of yellow, yellow-orange, and orange because any blue in the admixture will turn them green.*

An achromatic dark is one that appears to have no temperature bias: a pure black or dark gray. (Black and white pigments are, in truth only relatively achromatic. Each one has a slight temperature bias. Nevertheless, the distinction between mixed chromatic darks and commercial black paints is a meaningful one: especially in intermixture, as you will see as the course develops.)

Mass Tone and Undertone

When working with opaque paints, such as oil, acrylic, or gouache, there are two ways to read a color. When paint is applied as an opaque film, the color we see is called its *mass tone*. Mixing the same color with white, diluting it to a transparent consistency, or scraping it away reveals its *undertone*.

The mass tones and undertones of most colors are similar, but the hues of very dark colors are more easily seen in their undertones. Sometimes the mass tone and undertone of a color can look different, as with alizarin crimson, which has a deep crimson mass tone but a red-violet undertone (fig. 4.1).

Tinting Strength

The "tinting strength" of a color is the extent to which it can affect another color when mixed with it. Some colors, such as phthalocyanine blue, have a powerful tinting strength while others, like most yellows, are weak. Whites, too, are weak, but some are weaker than others. A controlled way to test the tinting strength of a color is to standardize the quantities in the test; i.e., mix a fixed quantity of color with a fixed quantity of white. For those of a less scientific bent, simply paying attention as you work with your paints will soon make their relative strengths apparent. In general, dark colors are stronger than light ones.

Relative tinting strength becomes important when intermixing colors. The rule of thumb is to *always mix strong into weak, never weak into strong*. For example, when mixing a prismatic green by combining phthalocyanine blue with yellow light, add the blue (very carefully) to a quantity of yellow. A very small amount of phthalocyanine blue will have a strong effect on any yellow. Likewise, if you are trying to make a very light version of a color, add a small amount of that color to the white, not the other way around.

4.1 Alizarin Crimson: mass tone and undertone.

4.2 Cool chromatic dark with mass tone and undertone made with a palette knife on marker paper.

4.3 Cool and warm chromatic darks with mass tones and undertones.

HANDMADE ASSIGNMENT 1: EXPLORING CO-PRIMARIES

Rationale: The first assignment below explores the co-primaries and introduces the mixing, cutting, and mounting procedures you will be using throughout the course. You will be creating chromatic darks and secondary colors to understand the effect of hue overtones on color mixing.

1A. Chromatic Darks

Two chromatic darks will be used as admixtures through-out this course, one warm and the other cool. Payne's gray straight from the tube will be the cool dark and either raw or burnt umber will serve as the warm dark. If Payne's gray is unavailable make a cool dark by mixing ultramarine blue with a little burnt umber.

Place each of the two dark tones on a paper palette and transfer them to the marker paper using a palette knife. Put the paint down opaquely as "mass tone" and then scrape it across the page to show "undertone." A single swatch will look something like figure 4.2 when painted. The finished, trimmed versions of the warm and cool chromatic darks will appear as in figure 4.3. These swatches need only be about 2 inches square (5 cm). You will be cutting 1 inch (2.5 cm) squares out of them for mounting.

1B. Mixing Two Versions of the Secondary Triad: Green, Orange, and Violet

Before mixing prismatic secondaries look back at Part Three, figure 3.3, which shows each co-primary and its secondary overtone.

Make a pure, *prismatic* green with a warm blue (phthalo or equivalent) and a cool yellow (yellow light). These are the co-primaries that are biased toward green.

Next, make a duller, muted color green by mixing the cool blue (ultramarine) and warm yellow (yellow deep). These two colors are biased toward violet and orange respectively, which is why the resulting green is an olive color and not a pure version of the hue. As with the chromatic darks, transfer the colors to the marking paper with the palette knife to show mass tone and scrape to reveal undertone.

Scan here for video demonstration.

CHROMATIC DARKS

Payne's gray

burnt umber

GREEN

warm blue + cool yellow

cool blue + warm yellow

ORANGE

warm red + warm yellow

cool red + cool yellow

VIOLET

cool blue + cool red

warm blue + warm red

*Refer to color temperature chart on p.33 for the appropriate color name according to brand.

4.4 Assignment 1 shown as it would look on card stock.

Now make two oranges, as you did with green: a prismatic version and a muted color. The prismatic version should be made with the warm red (a scarlet red, e.g., napthol red light) and warm yellow (yellow deep). Both are biased toward orange. The second orange, a muted color, should be made with cool red (alizarin or equivalent) and cool yellow (yellow light). The dullness of this orange will be more subtle than the muted green, but it will still be perceptibly softer and less vibrant than a pure, prismatic orange. Again, transfer with the knife to marker paper and show both mass tone and undertone.

Finally, make two violets, a prismatic version and a second version, which you will find surprisingly dark and dull. Make the prismatic violet with cool red (alizarin) and cool blue (ultramarine). Both are biased toward violet. Make the darker variation with warm red (napthol red light, which is biased toward orange) and warm blue (phthalocyanine, biased toward green).

When all eight swatches are dry on the marker paper, place the page under a heavy book for about an hour to flatten. (This will always be part of your process whenever you are using swatches in a study.)

After flattening, cut 1-inch (2.5-cm) squares of each swatch and mount them on white card stock. Make sure each square shows mass tone and undertone. See figure 4.4 for a view of the finished study. Label by hand the colored squares with the names of their ingredients where shown.

ALTERING COLOR ATTRIBUTES THROUGH INTERMIXING

A prismatic (or pure) color's value and saturation can be adjusted by mixing it with white, chromatic dark (or black), or its complementary color, as shown in figure 4.5.

In altering the value of a prismatic color, you also change its saturation. For example, adding white to any prismatic color will lighten it, but simultaneously lower its saturation; that is, make it less pure. (The addition of white to a color turns it into a TINT.) Adding chromatic dark, black, or a color's complement will both darken it and lower its saturation. (Adding black to a color creates a SHADE.)

If you want to lower the saturation of a pure color without altering its value, make sure that the value of the admixture is the same as that of the original pure color, as shown in figure 4.6.

For the next assignment you need to know that muted colors and chromatic grays are made the same way: by combining a prismatic color with white, chromatic dark, a combination of chromatic dark and white, or its complement. The difference between mixing a muted color and a chromatic gray lies in the proportions within the mixture. Chromatic grays are less saturated than muted colors. Therefore, to make them you must add more of the dulling admixture to the prismatic color than you would use to make a muted color.

HANDMADE ASSIGNMENTS 2–5: SATURATION STUDIES

Rationale: One should fully understand the three attributes of color (hue, value, and saturation) and, more importantly, be able to think of them independently when planning or assessing color applications. Assignments 2–5 require you to think about all three attributes but with a particular emphasis upon the relationship between saturation and value.

To prepare for assignments 2–5, you will need to paint a total of 42 rectangular swatches on marker paper as shown in figure 4.7. Swatches should each be roughly 4.5 x 5 inches (10.2 x 12.7 cm.). Try to include all primary and secondary hues when possible.

→ Make swatches of 18 *muted colors*: six light, six mid-tone, and six dark.
→ Make swatches of 18 *chromatic grays*: six light, six mid-tone, and six dark.
→ Make swatches of six *prismatic colors*.

Monitor the values of the colors you are mixing by comparing them to the values on your grayscale. Always wait until the paint is dry before making those comparisons (most colors look about 8 percent darker when dry).

When your pages of swatches are dry, flatten them under heavy books for at least an hour. After flattening, cut them apart and organize them into two categories of saturation (muted color and chromatic gray). Divide those subsets into three categories of value: light, mid-tone, and dark.

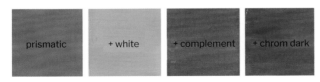

prismatic + white + complement + chrom dark

4.5 Prismatic green altered through the addition of white, red, and a chromatic dark.

4.6 A prismatic green dulled in saturation but not altered in value by using an admixture (in this case a cool chromatic gray) that is the same value as the original green.

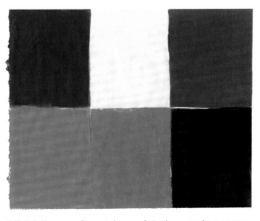

4.7 A full page of swatches painted on marker paper.

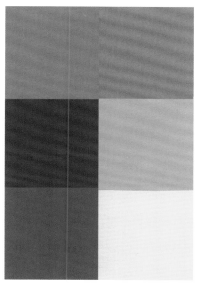

4.8 Assignment 2A: muted colors — broad value range. Nurjahan Kahn.

4.9 Assignment 2B: muted colors — narrow value range. Nurjahan Kahn.

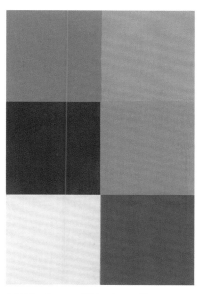

4.10 Assignment 3A: chromatic grays — broad value range. Yana Senchylo.

4.11 Assignment 3B: chromatic grays — narrow value range. Yana Senchylo.

2A. Muted Color Study: Broad Value Range

From your muted color swatches cut six 2 x 2 inch (5.1 cm) squares and glue them to white card stock in a 4 x 6 inch (10.2 x 15.2 cm) grid. This arrangement should show a *broad value range* that includes dark, mid-tone, and light muted colors. Try to use six different hues. See figure 4.8.

2B. Muted Color Study: Narrow Value Range

From your muted color swatches cut six 2 x 2 inch squares and glue them to white card stock in a 4 x 6 inch grid. All colors should be *close in value*, within two steps of each other on the grayscale. Again, use six different hues. See figure 4.9.

3A. Chromatic Gray Study: Broad Value Range

From your chromatic gray swatches cut six 2 x 2 inch squares and glue them to white card stock in a 4 x 6 inch grid. This arrangement should show a *broad value range* that includes dark, mid-tone and light chromatic grays. Include a broad hue range. See figure 4.10.

3B. Chromatic Gray Study: Narrow Value Range

From your chromatic gray swatches cut six 2 x 2 inch squares and glue them to white card stock in a 4 x 6 inch grid. All colors should be *close in value*, within two steps of each other on the grayscale. Maintain a broad hue range. See figure 4.11.

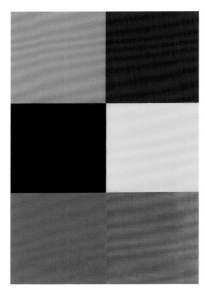

4.12 Assignment 4: A grid of six prismatic colors. Nurjahan Kahn.

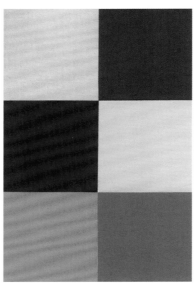

4.13 Assignment 5A: muted color, chromatic gray, and prismatic color with a broad value range. Yana Senchylo.

4.14 Assignment 5B: muted color, chromatic gray, and prismatic color with a narrow value range. Yana Senchylo.

4. Prismatic Color

From your prismatic color swatches cut six 2 x 2 inch (5.1 cm) squares and glue them to white card stock in a 4 x 6 inch (10.2 x 15.2 cm) grid. Remember that prismatic colors are locked into their values. Make sure you use six different hues. See figure 4.12.

5A. Combined Saturation Levels Study: Broad Value Range

From your swatches representing all three levels of saturation, position and glue to white card stock six 2 x 2 inch squares into a 4 x 6 inch grid. This arrangement should have a *broad value range* that includes dark, mid-tone, and light colors at each level of saturation. Use six different hues. See figure 4.13.

5B. Combined Saturation Levels Study: Narrow Value Range

From your swatches representing all three levels of saturation, position and glue to white card stock six 2 x 2 inch squares into a 4 x 6 inch grid. All colors should be *close in value*, within two steps of each other on the grayscale. Maintain a broad hue range. See figure 4.14.

Technical Tips

Your swatches should be as clear, smooth, and opaque as you can make them. The examples of studies you see in this book have been hand-painted by students in classes and color workshops. You may see a little streaking and some imperfect cutting. Concentrate your effort on the color lesson and don't fret about subtle imperfections. Remember that gouache and acrylic gouache tend to dry a little darker than they appear when wet (except for the darkest colors, which lighten a little in drying). Always wait until your colors are dry before assessing them. In time you will learn to anticipate these changes with reasonable accuracy.

Reading the Grayscale

Keep your grayscale handy throughout this course; it will help you accurately assess the value of an individual color and the range of value relationships in a study. Figure 4.15 demonstrates how to read the value of a color using a grayscale. A casual glance at the muted orange tells you that it is in the mid-tone range. Looking closer, you can see which section of the grayscale matches the color most precisely. Look for the degree of contrast you see where the grayscale

4.15 Matching a color with the grayscale.

and the color meet. The most saturated colors are a little more difficult to read than duller ones because the strong saturation contrast between a prismatic color and the achromatic grays on the scale can be visually confusing at first. *It helps to squint a little when making this comparison.*

The Richness of Muted Colors

Muted colors range in saturation from nearly pure to subtle colors that verge on chromatic gray. Figure 4.16 shows a William Morris floral pattern in muted colors against a black background. The overall coloration is naturalistic and suggestive of lush growth.

4.16 William Morris, *Golden Lily*, 1870. Hand-printed woodblock paper. Private collection, London.

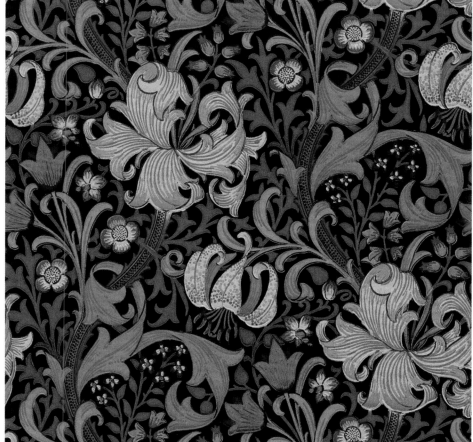

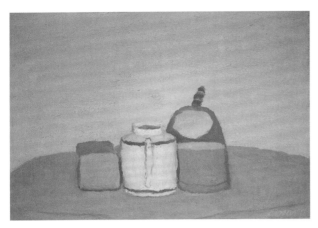

4.17 Giorgio Morandi, *Still Life*, 1949, oil on canvas. Museo Morandi, Bologna.

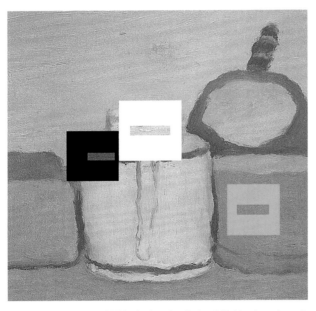

4.18 Detail of figure 4.17 isolating the darkest, lightest, and most saturated tones in the painting.

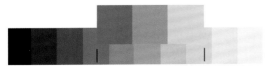

4.19 Isolated tones from figure 4.18 seen against a grayscale.

Limited Contrast Lends Emphasis to Subtle Color Differences

When color attributes are constrained to a narrow range, our eyes tend to register subtle distinctions. The still-life paintings of Giorgio Morandi, whose typical palette is limited to chromatic grays with an occasional touch of muted color, exemplify this. Although his color is subdued, he orchestrated his grays to maximize their differences in temperature, which gives his slightly more saturated colors surprising emphasis. Morandi's painting (fig. 4.17) makes effective use of minimal value and saturation contrast. The "dark" stripes on the "white" pitcher create a visual accent, as does the orange-tinged chromatic gray canister to the right.

In the detail of Morandi's painting shown in figure 4.18, specific color areas are isolated for easy comparison. The black square sets off the darkest color in the painting and reveals it to be a mid-tone in value, not as dark as it seems. Similarly, when the lightest tone in the painting is seen against a pure white square, it turns out to be only a few steps in value lighter than the darkest color. The orange tone is particularly interesting. It is the richest color in the painting, but against a prismatic orange square it appears to be a chromatic gray. Figure 4.19 shows the same three tones against a grayscale to demonstrate the narrow value range of Morandi's painting.

4.20 Ellsworth Kelly, *Red Blue Green*, 1963. Oil on canvas. Museum of Contemporary Art, San Diego.

How Prismatic Colors Function

Prismatic colors are emphatic, like the crisp blast of a trumpet. Compared to muted colors and chromatic grays, they are also inflexible. Both muted colors and chromatic grays offer the possibility of great variation; each allowing myriad degrees of saturation and value. But prismatic colors have only one specific level of saturation: the purest version of that color. And each pure color is locked into its value. You cannot alter the value of a prismatic color without either lowering its saturation or shifting its hue.

The painting by Ellsworth Kelly shown in figure 4.20 employs prismatic colors exclusively. For this stark minimalist work, Kelly chose the hues of the additive primary: red, green, and blue.

Figure 4.21 shows a painting by William L. Hawkins that prominently features prismatic color with the crisp support of black and white. The boldness of his color fortifies the exhilaration of Hawkins' vision. Notice the surrounding border of red, yellow, black, and blue.

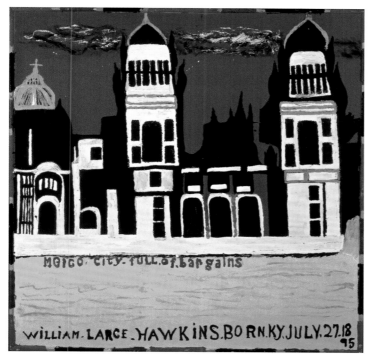

4.21 William L. Hawkins, *Mexico City Full of Bargains*, 1989, enamel house paint on paneling. Gift of Carl D. Lobell and Kate Stettner to the American Folk Art Museum.

EXECUTING ASSIGNMENTS ON THE COMPUTER

It is possible to execute most of the studies in this course digitally in Adobe Photoshop. If you are familiar with that program, I recommend that you follow up the handmade work with digital studies to reinforce your understanding.

One of the fundamental ideas behind this course is that color can be more fully understood if you "build" it through color mixing rather than finding it in the form of colored papers. In Photoshop there are several swatch palettes in which you can "find" a color. These are very convenient but, for absorbing the lessons of this course, they are not useful. You will get more out of your digital studies if you build your colors on the CMYK sliders.

Always use CMYK, not RGB, sliders when making studies for this course. Cyan and magenta correspond closely enough to blue and red to enable you to work intuitively while building your colors on the sliders. The RGB sliders, on the other hand, are linked to additive color theory and require an entirely different logic.

In figure 4.22A CMY are all lined up vertically at 50 percent. Whenever all three primaries are in line, they make a warm chromatic gray, something like raw umber. The value of that gray is determined by how far to the left or right the aligned colors are positioned on the slider. Figures 4.22B and C show light and dark versions of that neutral earth tone with the sliders lined up at either end of the scale.

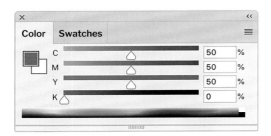

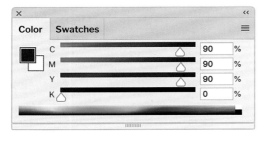

4.22A–C Whenever cyan, magenta, and yellow are lined up they make a warm chromatic gray. The darkness of the gray is determined by its lateral position on the slider.

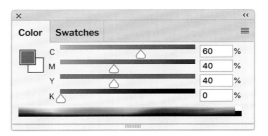

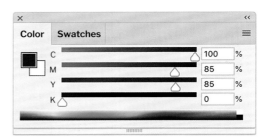

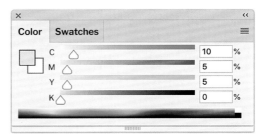

4.23A–C A cool chromatic gray results when cyan is pulled out of the vertical alignment, to the right.

To make a cool, dull chromatic gray, from the vertically aligned position, simply pull cyan slightly out to the right. Figures 4.23A, B, and C show three cool chromatic grays: a mid-tone, a dark, and a light version.

Figures 4.24A and B show two mid-tone blue-violets. We see a muted color above and, below, a chromatic gray. The difference between them is the position of the yellow (the complement of violet). Moving the yellow slider to the right strengthens its effect on the outcome and dulls the muted color down to a chromatic gray.

Regarding Sliders in Terms of Hue

The numbers that appear in the boxes to the right of the sliders indicate how much cyan, magenta, yellow, or black (K) is present in the color being constructed. As with pigments, in CMYK the only one-part colors are the primaries, cyan, magenta, and yellow. But the red and blue you know from the RYB primary triad are made in two parts when using the CMYK sliders. Figures 4.25A and B show a medium red made by combining magenta with yellow, and a cobalt blue composed of magenta and cyan.

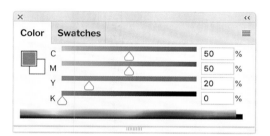

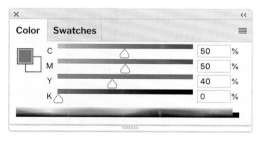

4.24A, B Two mid-tone blue-violets: a muted color on the top and, above, a chromatic gray.

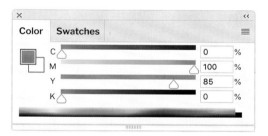

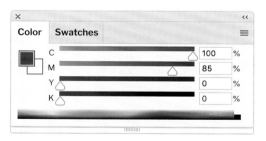

4.25A, B A medium red made with magenta and yellow and cobalt blue made with cyan and magenta.

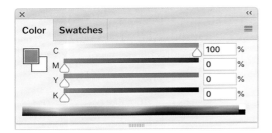

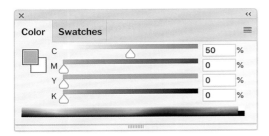

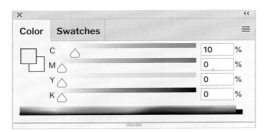

4.26A–C Sliding 100% cyan to the left is like adding white to the color. It lightens the value and reduces saturation.

Regarding Sliders in Terms of Value

With any color, changes in value are determined by moving sliders to the left or right: Move to the left to lighten and to the right to darken a color. If you move all sliders involved in a color simultaneously to precisely the same degree, you will alter its value without changing its hue. Figures 4.26A, B, and C show three sliders indicating three versions of cyan. The first shows the hue at prismatic level. The second and third move the slider to the left. Each move left lightens the cyan and diminishes its saturation. Moving sliders to the left simulates the adding of white to a color.

Regarding Sliders in Terms of Saturation

When using a single slider (say, cyan), moving the slider to the right will strengthen its saturation while simultaneously darkening its value. Pushing the slider all the way to the right will achieve 100 percent saturation.

With two- and three-part colors (excluding the black slider, which doesn't contribute hue), the same holds true. Moving the sliders to the right will increase the color's saturation and darken its value. (Three-part colors that are vertically aligned will only get darker as their sliders are moved to the right, not more saturated.)

Using the Black Slider

The black slider (or K) makes it easy to darken and dull colors – simply move it to the right. Used alone, it produces achromatic grays in all values. Unlike black pigment, the addition of K tone to digital color has no deleterious effect on the clarity of the resulting shade. For the fullest understanding of color composition however, limit your use of the black slider to 10 percent in any color you create for these studies.

DIGITAL ASSIGNMENTS 1–4: SATURATION STUDIES

1A. Muted Color Study: Broad Value Range

Using sliders, create a grid of six 2 x 2 inch (5.1 cm) *muted color* squares in a *broad value range*. Use six different hues. See figure 4.8.

1B. Muted Color Study: Narrow Value Range

Create a grid of six 2 x 2 inch *muted color* squares in a *narrow value range*. All colors should be within two steps of each other on the grayscale. Use six different hues. See figure 4.9.

2A. Chromatic Gray Study: Broad Value Range

Create a grid of six 2 x 2 inch *chromatic gray* squares in a *broad value range*. Maintain a broad hue range. See figure 4.10.

2B. Chromatic Gray Study: Narrow Value Range

Create a grid of six 2 x 2 inch *chromatic gray* squares in a *narrow value range*. All colors should be within two steps of each other on the gray scale. Maintain a broad hue range. See figure 4.11.

3. Prismatic Color Study

Create a grid of six 2 x 2 inch *prismatic color* squares. Maintain a broad hue range by including both warm and cool colors. See figure 4.12.

4A. Combined Saturation Levels Study: Broad Value Range

Create a grid of six 2 x 2 inch squares representing *all three levels of saturation*. This arrangement should have a *broad value range* that includes dark, mid-tone, and light colors at each level of saturation. Maintain a broad hue range. See figure 4.13.

4B. Combined Saturation Levels Study: Narrow Value Range

Create a grid of six 2 x 2 inch squares representing *all three levels of saturation*. This arrangement should have a *narrow value range*. All colors should be within two steps of each other on the grayscale. Maintain a broad hue range. See figure 4.14.

COLOR ON THE SCREEN AND IN PRINT

As previously discussed, color on the screen is brighter and the distinctions between colors are coarser than they are in print. For example, even though a hue should only be prismatic at 100 percent, it is hard to recognize diminishing saturation on the screen until you move the slider below 90 percent. Images on the screen are always lively but lack subtle nuances. Eye fatigue is a factor. Looking into a screen is like staring at a low-wattage light bulb. After a while, one inevitably loses some ability to discern subtle distinctions. For that reason, it is a good idea to print out your color studies on good quality inkjet paper, e.g., Epson's matte presentation paper.

PART FIVE COLOR SCHEMES & COLOR PROPORTION

IN PART FIVE YOU WILL

→ Identify major color schemes.

→ Demonstrate all attributes of color in four distinct schemes.

→ Recognize the effect of proportional variation within a set number of colors.

→ Design four proportional variations on a group of four colors.

Color does not add a pleasant quality to design – it reinforces it.—Pierre Bonnard

ORGANIZING COLOR SCHEMES

In the broadest sense the term "color scheme" refers to any fixed set of hues employed exclusively in an image or design. However certain color combinations have become standard over time. The most common of these are MONOCHROMATIC, ANALOGOUS, COMPLEMENTARY, and TRIADIC color schemes. Other notable arrangements involve split-complementary and cross-complementary hue relationships. All color schemes may include not only prismatic colors but also a full range of tonal variations. (By TONE we mean any altered version of a prismatic color. For example, all muted colors and chromatic grays are tones.)

Monochromatic

Color schemes that are based upon any one specific hue on the spectrum are monochromatic. For example, the hue red ranges from crimson to scarlet,

between which lie a large number of discernibly distinct prismatic reds. Red tones can extend in value from a very dark chromatic gray to a light pink and the possible range of saturation can run from prismatic red to dull red-grays. Figure 5.1 shows a grid of 16 variations of the color red. Monochromatic schemes are extremely cohesive.

Analogous

Hues that lie adjacent to each other on the color wheel form the basis of analogous color schemes. Although its range can be considered somewhat flexible, an analogous scheme typically contains three colors in sequence on a 12-part wheel. Figure 5.2 shows an analogous arrangement of 16 tones derived from blue-green, blue, and green. As with all color schemes, a full range of value and saturation is available.

5.1 A monochromatic color scheme.

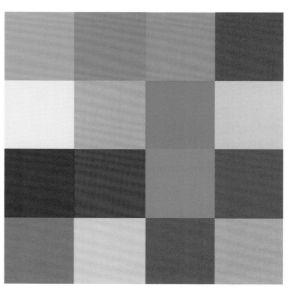

5.2 An analogous color scheme.

Complementary

Complementary color schemes are built around any two hues that fall directly opposite each other on the color wheel. Complementary hue pairs have a distinctive effect upon each other. When intermixed, they produce a darker and duller color; both value and saturation are diminished through intermixing. But when placed next to each other, they generate visual energy. Figure 5.3 shows 16 tonal variations of the complementary pair blue and orange.

Triadic

Any three hues that are spaced at equal distances on the color wheel constitute a triad. The primary and secondary triads are iconic, but there are potentially innumerable three-hue equilateral triangles. The grid of colors in figure 5.4 contains the secondary triad (green, orange, and violet) and 13 tones derived therefrom.

HANDMADE ASSIGNMENT 6: FOUR COLOR SCHEMES

Rationale: In this assignment you will explore monochromatic, analogous, complementary, and triadic color schemes.

All four studies should have the same dimensions whether square or rectangle. Ideal sizes are around 25–35 square inches (63.5–83.9 sq. cm). Cut a template from card stock as shown on page 36 (figure 3.6) so that you can easily pencil in outlines for your four backgrounds.

The background color will be part of your design, so ensure it is visually consistent with the specifications of the assignment. When painting a background color be sure to make a swatch of the same color on marker paper so you can bring the background to the foreground later in the design process if needed.

The studies in this assignment are done in a grid format. Each study contains 12 distinct tones, counting the background color. You can make the strips of color run all the way across the design or vary the design of the grid to your liking.

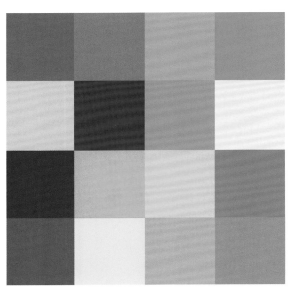

5.3 A complementary color scheme.

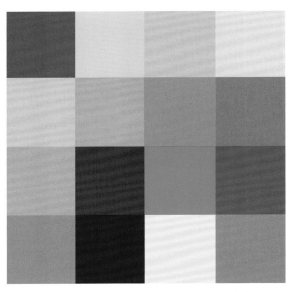

5.4 A triadic color scheme using the secondary triad.

6A. Monochromatic Color Scheme

Choose one hue for your monochromatic color scheme. Paint a background on card stock in that color. Note that the background need not be a prismatic version of your chosen color and it can be of any value or saturation. In strips, paint 11 tonal variations of your chosen hue on marker paper. Cut out and paste the strips to your background to make a grid-based composition. (You should include your prismatic original color among the 11 tones.)

Figure 5.5 shows a monochromatic study in blue. The blues range from ultramarine to phthalocyanine blue. The range of values is broad, from very light to nearly black. The saturation range is also broad and includes blues at all three levels: prismatic color, muted color, and chromatic grays. The background color is a muted mid-tone version of ultramarine blue.

In figure 5.6, illustrator Bex Glendining employs a monochromatic color scheme to lend a magic realist, moonlit quality to a commonplace scene.

5.5 A monochromatic color study. Elise Weber.

5.6 An illustration in blue monochrome. Bex Glendining, *Night Street*, 2018.

6B. Analogous Color Scheme

Choose three adjacent prismatic colors from the color wheel. Paint a background derived from one of those colors using the same size and shape format as in Assignment 6A. As before, paint a total of 11 tones based upon your three analogous hues in strips on marker paper. Cut and paste the strips to your background color in a grid design. (You should include prismatic versions of each original color among the 11 tones.)

Figure 5.7 shows an analogous color scheme in yellow, yellow-green, and green. Notice that the range of value and saturation are both broad.

In figure 5.8 a painting by Deborah Zlotsky shows analogous colors used in combination with forceful geometric imagery.

5.7 An analogous color study. Dawon Kim.

5.8 Deborah Zlotsky, *Tragedy tomorrow, comedy tonight*, oil on canvas, 2012. Courtesy of the artist.

6C. Complementary Color Scheme

Choose two prismatic complementary hues. Using the same format as in Assignments 6A and 6B, paint a background derived from one of the complementary colors on card stock. Then paint strips with 11 variations of the original complements on marker paper and paste them to your background in a grid formation. (You should include prismatic versions of your two complements among the 11 tones.)

Figure 5.9 shows a complementary color scheme in red and green. As before, we see a broad range of value and saturation. There are cool and warm prismatic reds and the background is a dark, relatively dull green.

The plaid textile design shown in fig. 5.10 is based on red and green. Pristmatic versions of each hue are present as is a rich tonal array of muted colors and chromatic grays.

5.9 A complementary color study. Elise Weber.

5.10 Red and green abstract plaid seamless pixel pattern.

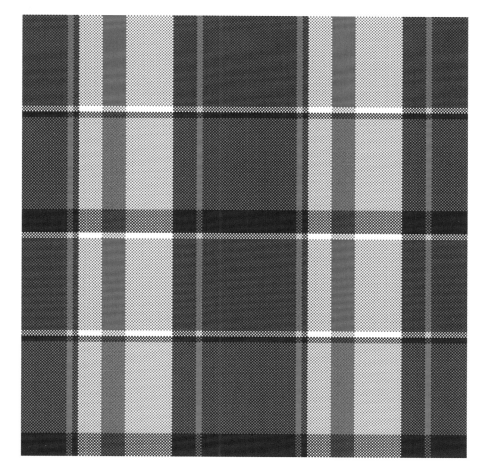

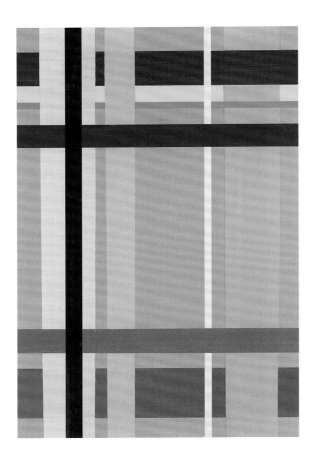

6D. Triadic Color Scheme

Choose a triadic color scheme. It can be three primary, three secondary, or three tertiary colors. Once you have selected your triad, paint a background derived from one of its hues on card stock. Paint 11 tonal variations of your triad on marker paper. Cut and paste those strips to your background in a grid-based design. (You should include prismatic versions of any or all of your triad among the 11 tones.)

The example in figure 5.11 shows a triadic study in primary colors. You can see light and dark tones of each color along with pure prismatic colors, muted colors, and chromatic grays. The background here is a mid-tone, yellowish chromatic gray.

A painting by Todd McKie (fig. 5.12) capitalizes on the play-fulness we associate with the primary triad to match color mood with content. The warm chromatic gray background was made by intermixing the bright red, yellow, and blue you see in the painting.

5.11 A triadic color study. Elise Weber.

5.12 Todd McKie, *We Need To Talk*, vinyl paint on canvas, 2004. Courtesy of the artist.

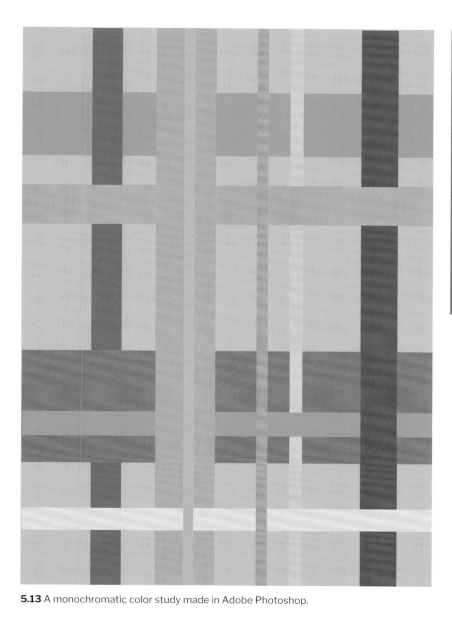

5.13 A monochromatic color study made in Adobe Photoshop.

DIGITAL ASSIGNMENT 5: FOUR COLOR SCHEMES

Follow the instructions for the hand-painted studies but make them in Photoshop. As in all digital studies, use the CMYK sliders to construct your designs. Begin with a background color and use the "Rectangle Tool" to create strips of appropriate tones. Using a different layer for each strip gives you the ability to move elements independently as you would with strips of paper. Figure 5.13 shows an orange monochromatic study made in Photoshop.

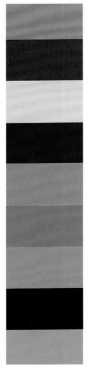

5.14 The nine colors used in 5.15–17.

5.15 A, B Comparing different color proportions using the same nine colors.

COLOR PROPORTION

The proportional relationships in a group of colors strongly influence their overall visual effect. Figure 5.14 shows a stack of nine diverse colors. In figures 5.15A and B those colors are applied to the same design twice. In 5.15A, the dominant color is a highly saturated mid-value orange, which is placed against its complement, a bright blue. A third strong color, yellow green, is nestled between them. This is a bold version of the design.

In 5.15B, a dull, dark violet that played only a small role in the previous version now dominates the composition. The purest colors here cover small areas and are kept apart. This shift in proportions quiets the design, lending it an almost nocturnal quality.

The dramatic difference in these two studies depends upon a broad range of hue, value, and saturation in the group of colors. Figures 5.16A and B show the same design with the same hues. But the values and saturations show less contrast; all the colors are chromatic gray. As a result, the two designs appear more alike and the effect of the change in proportion is less pronounced.

In figures 5.17A and B the same hues appear again, but this time the range of saturation is limited to prismatic or near prismatic colors and the value range is also narrow. Here, as in figure 5.16, the effect of proportional difference has less impact on the mood of the design.

 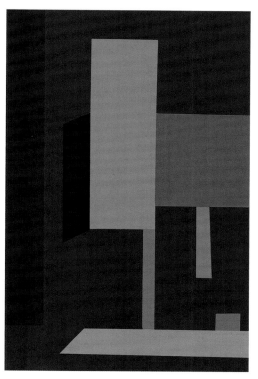

5.16A, B Comparing different color proportions using the same nine colors, all chromatic grays.

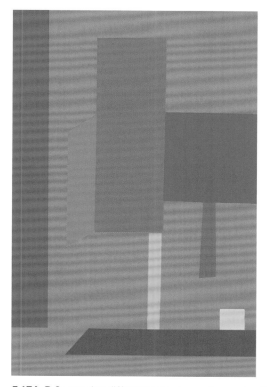 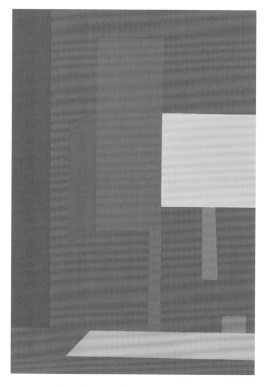

5.17A, B Comparing different color proportions using the same nine colors, all prismatic.

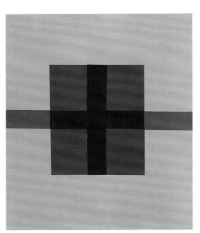
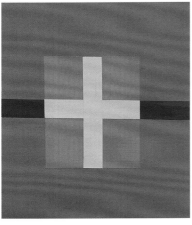
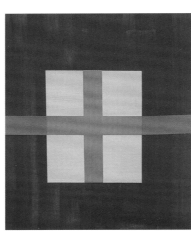

5.18 Four proportional studies. Anna Daly.

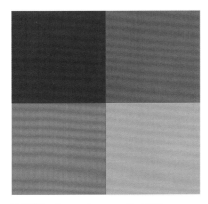

5.19 The four colors used in 5.18.

HANDMADE ASSIGNMENT 7: STUDY IN PROPORTIONAL VARIATION

Rationale: In this assignment you will explore the surprising impact of proportional variation.

The best way to begin this assignment is to paint single-color backgrounds of identical size and shape on four separate pieces of card stock. Use removable tape to mask out your rectangle for painting. When choosing the four colors, make each one clearly individual, with a broad range of hue, value, and saturation among them.

As you paint each background, make a swatch of the same color on marker paper. When you have finished your backgrounds, you will also have four swatches, one of each color, to use in your designs. (The background color will always be one of the four colors included.)

Cut shapes from the swatches to create four versions of the same design. Each color should appear in a different location in each version. Designs that use concentric squares or circles work well here, but choose a different configuration if you wish. *Make sure that the four shapes in your design are of four distinct sizes, ranging from large to small in proportion to the whole.*

Figure 5.19 shows swatches of the four colors used in figure 5.18.

5.20 Valerie Maser-Flanagan, *Growth Rings #1*, fiber, 2015. Courtesy of the artist.

In her textile construction shown in figure 5.20, Valerie Maser-Flanagan makes dramatic use of proportional variation. Each of the four concentric circles is composed of the same colors, but the proportions shift from circle to circle.

DIGITAL ASSIGNMENT 6: STUDY IN PROPORTIONAL VARIATION

To do the digital version of this study, simply make your first design and then copy it. Working with the original and its copy side by side, use the "Eyedropper Tool" to create proportional variations in the copy. Repeat until you have four variations. Print each one on a separate sheet of paper.

PART SIX COLOR INTERACTION

IN PART SIX YOU WILL

→ Recognize how the appearance of a color depends upon its surroundings.

→ Assess the way each color attribute can be altered independently by changing its context.

→ Practice arranging colors to discover the logic behind their interaction.

→ Illustrate color interaction in a series of examples.

In visual perception a color is almost never seen as it really is – as it physically is. This fact makes color the most relative medium in art. —Josef Albers

6.1

6.2

AFTERIMAGES

Painters commonly experience the surprise of mixing a color on the palette and then seeing it change when it is placed among other colors in a painting. This is because the appearance of a color is affected by its neighbors, sometimes subtly, sometimes dramatically. There is an aspect of vision that causes a halo effect called an AFTERIMAGE to appear to surround individual chromatic and achromatic shapes. We are not normally conscious of this optical illusion, but it is present wherever one color meets another on a flat surface. In fact, despite our lack of awareness of them, the cumulative effect of multiple afterimages in a painting or a design enriches the effect of color combinations. To explore this phenomenon, we'll conduct a few optical experiments.

To begin, stare at the black circle on the left (fig. 6.1) for about ten seconds while trying to keep a relaxed eye. Then shift your gaze to the white area within the box below the circle (fig. 6.2). The afterimage will appear as a very bright white circle the same size as the black one. This optical effect is called "successive contrast."

Now stare at the black circle again for several seconds. Again, shift your gaze into the empty square but this time, when you see the circular white afterimage, concentrate on its outer edge. The afterimage will itself be surrounded by a weak but perceptible dark-gray aura. What you now see is the afterimage of an afterimage. Optical echoes like this reverberate subtly throughout any combination of contiguous colors.

Finally, concentrate on the black circle and, without shifting your gaze, notice the bright white halo flickering around its edge. You should see that the black circle with its white nimbus resembles a solar eclipse.

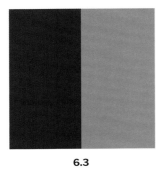

6.3

6.4

6.5

6.6

Achromatic Afterimages

Looking carefully where two colors meet you can see two simultaneous afterimages. Look closely for a few seconds at the border between the black and gray rectangles in figure 6.3. On the darker side of the border you will see an even darker band. At the same time, a lighter band will appear on the inside edge of the lighter rectangle. Figure 6.4 depicts how both afterimages can be seen simultaneously. This is known as SIMULTANEOUS CONTRAST.

Because achromatic grays lack hue and saturation, their mutual afterimages contain only value. The afterimage a dark gray will cast upon a light gray will be lighter in value than the light gray. Conversely, the afterimage cast by a light gray on a dark gray will be even darker than the dark gray it falls upon. The halo surrounding the black circle on a white page is whiter than white, and the black afterimage on the inner edge of the dot is blacker than black.

Afterimages in Full Color

The lightness or darkness of an afterimage cast by a color conforms to the same rules that govern afterimages produced by black, white, and achromatic grays. So dark colors project lighter afterimages upon light colors. The difference with color, however, is that the afterimage also contains hue.

Look for ten seconds at the blue circle in figure 6.5 and then shift your attention to the white box (fig. 6.6). Again, the afterimage within the square is lighter than the white of the page. It also has a discernible orange hue: the complement of blue.

If the blue circle is placed against a lighter achromatic gray (fig. 6.7) the afterimage that surrounds it will contain its complement (orange) but will also be lighter than the gray it falls upon. Furthermore, if you look closely, you will see that the inside edge of the blue circle reveals a thin ring of darker blue. The gray, being achromatic, influences only the value of the blue and not its hue. Figure 6.8 illustrates the corona that surrounds the blue circle and the darker blue ring within the circle.

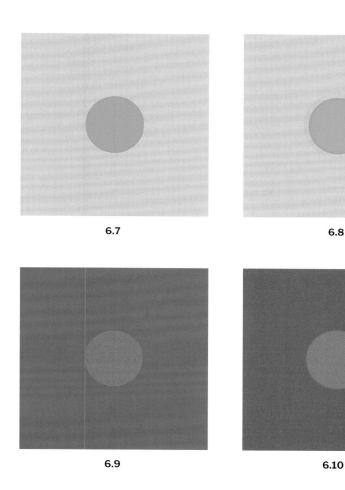

6.7

6.8

6.9

6.10

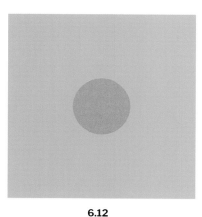

6.11

6.12

Look closely at the blue-violet circle against the green square (fig. 6.9). The green field casts its reddish afterimage on the blue circle, making it appear red-violet. Compare the same blue against gray (fig. 6.10). Here, with no green to cast a red afterimage, the circle appears bluer.

In figure 6.11 a violet circle is seen against a dark red-orange and again in figure 6.12 against a light green ground. Against orange, the violet appears lighter and a little bluer than it does against pale green, where it seems to be redder. This is another example of how the complementary after-image of a larger color can flood a smaller one and alter its appearance.

Another way to think of this is that the background color is drawing out the color it shares with the superimposed smaller color. For example, in figure 6.11 orange and violet have the hue red in common. The orange draws out the redness in the violet making the unshared blue component more visible. In figure 6.12, the green ground shares blue with the violet circle. It pulls the blue down and makes the redness in the violet stand out. As Josef Albers wrote, "Any ground subtracts its own hue from the colors which it carries and therefore influences."

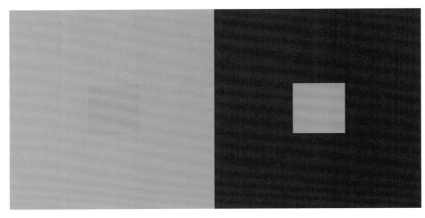

6.13

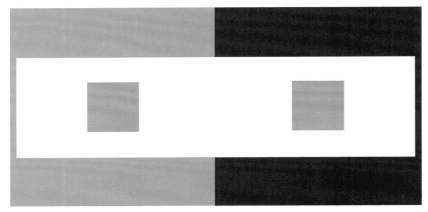

6.14

JOSEF ALBERS

Josef Albers was the most influential color educator of the second half of the twentieth century. He began his career at the Bauhaus in Germany, where he was a student and an instructor. Immigrating to the United States in 1933, he made his greatest impact on American art and design through his teaching at Black Mountain College and later at Yale University. In 1963, he published a limited-edition book of silkscreened color studies titled *Interaction of Color*. This seminal work was Albers' enduring pedagogical achievement.

The original edition is more than a book. It is a repository of discoveries made by Albers and his students over the course of several years' study. Albers' text reflects his sense of wonder at the mystery of color relationships.

One of Albers' classic experiments was to make one color appear as two. His favored motif was the square within the square. First, he would show what appeared to be two smaller squares of differing tones against two different background colors (fig. 6.13). Then he would mask out the backgrounds with white, revealing that the small squares were physically identical (fig. 6.14).

Albers was fascinated by the subtle and unpredictable nature of COLOR INTERACTION. He believed that only through sustained experimentation with color relationships could one attain a significant understanding of their intricacies.

6.15

6.16

Afterimages Enhancing a Pattern

Sometimes an afterimage can become an active part of a design, especially when repeated in a pattern. In figure 6.15 a light, achromatic gray field is covered by a grid of smaller, darker gray squares. Look at the intersections of the small squares and you will notice even smaller, vaguely square shapes emerging (as illustrated in the detail). Although an optical illusion, these flickering after-images play a role in animating the pattern design. Also note that the value of the afterimages is midway between that of the light-gray field and the small darker squares.

We can see the same phenomenon in figure 6.16 with orange and blue in place of the two achromatic grays. Here too the afterimage at the intersections enlivens the rigidity of the grid and, as in the gray grid pattern, its value is roughly halfway between that of the light-blue field and the orange squares. The afterimage combines the light blue of the background with the orange of the squares to make a duller orange that is lighter than the orange squares and darker than the light-blue background.

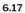

6.17

Interaction Against A Gradual Color Transition

When seen against a gradual color transition, the effect of color interaction on a single color can be dramatic. In figure 6.17 three horizontal stripes of identical blue-violet are transformed as they appear against a graded background.

The same dramatic effect can occur with colors in a stepped progression. Figure 6.18 shows how a single mid-tone chromatic gray can appear to change identity in relation to the tonal progression of the background.

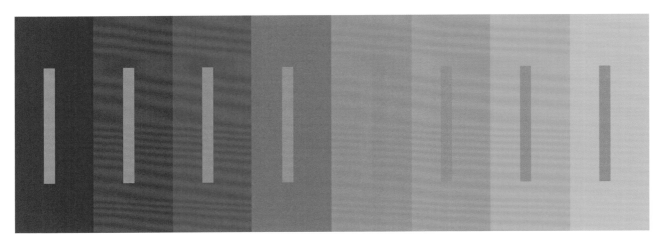

6.18

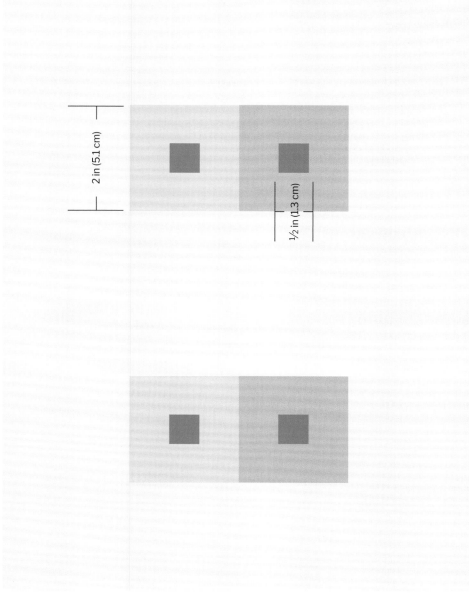

6.19 Layout for interaction studies.

HANDMADE ASSIGNMENT 8: COLOR INTERACTION STUDIES

Rationale: Because of the nature of color vision, a single color can appear to change in hue, value, or saturation when seen in different contexts. Sometimes the change is very subtle, sometimes it's dramatic. This assignment examines the optical influence that colors have upon each other and reveals some of the principles behind color interaction.

All four parts of Assignment 8 will use the same format: squares within squares. Center two examples on each page of card stock as shown in the layout diagram (fig. 6.19). The background squares should be 2 x 2 inches (5.1 x 5.1 cm) and the smaller squares ½ x ½ inches (1.3 x 1.3 cm).

Try to make a single color appear as two different colors by placing it against two different backgrounds. As before, use color swatches and collage construction for this assignment (you will have swatches saved from earlier assignments and you can mix new ones where needed). These experiments require close observation and repetition with small adjustments. As you observe color effects, reason out the cause. Try to vary your hue choices and saturation levels as you search for strong optical effects. Although the assignment calls for a total of only eight examples, take your time and try out many combinations before settling on the most compelling results.

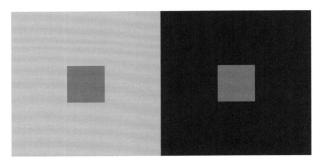
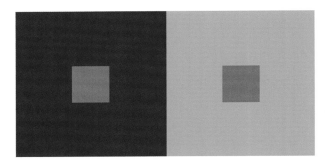

6.20 Altering the value of the center color so it appears darker on one side than on the other.

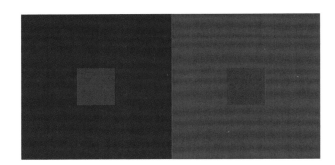

6.21 Altering only the hue of the center color.

8A. Value Shift

In the first two studies, try to emphasize a clear shift in the value of the small, superimposed color.

In figure 6.20 the value of the center color has been altered dramatically. Notice that the background colors contrast greatly with each other in value and that the value of the smaller squares is always midway between those of the background colors.

8B. Hue Shift

For the next two studies, try altering only the hue of a single color; its value should appear to remain the same. Again, be prepared to make many examples to get two excellent ones; explore colors at all levels of saturation. As you put together your color combinations, think about what you are seeing and try to understand it. Figure 6.21 shows two examples of center colors that are altered in hue, but not in value. Notice that the background colors are close in value.

8C. Saturation Shift

Make two studies that emphasize an alteration in saturation. Minimize, as much as possible, shifts in value. To alter saturation, use the same logic as when altering hue or value. Think about how a background color draws out what it has in common with the smaller color on top of it. In both examples shown in figure 6.22 the center square appears duller on the left and more highly saturated on the right.

8D. Hue and Value Shift

Produce two studies that appear to alter both the hue and value of a single color (fig. 6.23).

For an extra challenge, use what you have learned about color interaction to make two different colors appear as one (fig. 6.24).

 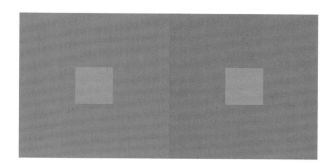

6.22 Altering the saturation of the center color.

6.23 Altering the hue and value of the center color.

6.24 Making two different colors appear more alike.

DIGITAL ASSIGNMENT 7: COLOR INTERACTION STUDIES

Working in Adobe Photoshop, make four interaction studies as described in Assignments 8A, B, C, and D above. Use the layout diagram (fig. 6.19) as a guide.

Once you have established the digital document you can use the "Magic Wand" tool to isolate a background color or, by holding the shift down as you select, isolate both center squares simultaneously. By going to "Image," and then to "Adjustments" and on to "Hue/Saturation," you can alter a selected color and watch it gradually change as you move any of the three sliders. (Pressing "Command H" will hide the dotted boundary around the selected color as you work on it.) You can, of course, also make color alterations on the CMYK sliders.

6.25 Six colors each appear twice as two different colors. Sarah Klotzer.

HANDMADE ASSIGNMENT 9: COMPOSITION WITH COLOR INTERACTION

Rationale: The goal of this assignment is to maximize the effect of a limited number of colors in a single design through color interaction and proportional variation.

Using six colors twice, create a design that demonstrates how a color's appearance depends on the color that surrounds it. As in the previous "one color as two" studies, arrange your color relationships to alter the way they look in each location. You can use color combinations from the previous assignment or make new ones to extend the challenge. The format should be no greater than 48 square inches (121.9 sq. cm).

In figure 6.25 six colors each appear twice as two different colors.

DIGITAL ASSIGNMENT 8: COMPOSITION WITH COLOR INTERACTION

Using the Photoshop techniques described on page 73, create a design in which six colors are each used twice to appear differently.

6.26

6.27

SEPARATING COLORS WITH LINE

Color shapes can be separated from each other by surrounding them with achromatic white, black, or gray, as in tiles that are separated by grout or stained glass held together with lead binding. Illustrators, especially in comic books and graphic novels, often surround shapes with black line and, by "coloring within the lines," isolate the colors. This makes them appear sharp and easy to read.

But isolating color with black line also prevents colors from interacting. The thicker the black or white boundary that separates them, the less colors can interact.

While separating colors inhibits their "conversation," white and black intervals each have a very different effect. To see these, relax your eye and stare at the white square against green in figure 6.26. You should notice a darker green just past the edge of the white. Keep looking and you will also see a light (lighter than the white of the square) afterimage at the inner edge of the square. This afterimage inside the square is of an almost neon red-violet hue. (You may also see this afterimage pouring out onto the white page around the large green square.) This demonstrates how a color's afterimage floods out into white.

Now stare at the black square against green in figure 6.27. Around the black square there is a nimbus of the same green in a lighter value. Within the square is only darkness – no perceptible afterimage cast by the green on black except a slightly darker gathering of blackness at the inner edge of the black square. This demonstrates how black holds colors within themselves.

6.28

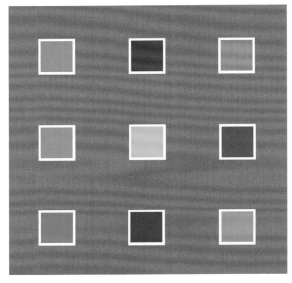

6.29

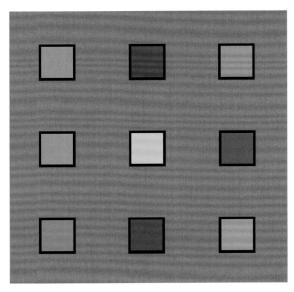

6.30

Figure 6.28 shows nine colors against a red field. These colors actively interact wherever they share an edge. In figure 6.29 the same colors are separated by white borders. Light afterimages pour out from the colored squares into the white lines and create a light, airy effect.

Figure 6.30 shows the same colors surrounded by black. Black borders confine colors while giving them a crisp legibility. Even the most randomly chosen, diverse colors tend to look cohesive when they are separated by black line.

Luminosity and Inherent Light

As we have said, luminosity refers to value, or the relative lightness of a color. Lightness and darkness are determined by the amount of light absorbed or reflected from a color's surface. Light colors like mint green, yellow, and pink are highly reflective and therefore relatively luminous whereas violet and dark brown are more absorbent and less luminous. Luminosity is physically measurable. In figure 6.31 colors build toward greater luminosity in the center square.

There is another way that color evokes light that is not physically measurable but is, nevertheless, an important aspect of color as it is applied to art and design. It is the sensation of light emanating from within color or INHERENT LIGHT. Whereas luminosity is a physical phenomenon, the experience of inherent light seems to be a psychological response. It can best be described as an inner glow that a color seems to have in relation to other colors. One would expect that the more saturated a color is, the stronger this sensation. But actually, the effect seems to depend upon a color's saturation in relation to its neighbors. For example, a muted color might glow when seen among a group of duller colors whereas a uniform group of prismatic colors would not produce the same effect. Value relationships also play a part. Inherent light seems most pronounced when colors are close in value and disparate in temperature. In figure 6.32 the colors build to a glowing blue at the center.

The colors in a stitched and printed textile by Michael James (fig. 6.33) appear to glow with inherent light.

6.31

6.32

6.33 Michael James, *Portal 2: Dungarpur* (verso), cotton and reactive dyes, pigments; digitally developed and printed; machine stitched, 2017. Courtesy of the artist.

PART SEVEN COLOR HARMONY

To emphasize only the beautiful seems to me to be like a mathematical system that only concerns itself with positive numbers.—Paul Klee

A MUSICAL ANALOGY

In music, the term "harmony" refers to the relationship between musical tones that are heard at the same time. Applied more generally, we tend to think of harmony as a state of concordance, where all parts are in sympathy with each other. But, in music, harmony can be concordant or discordant; i.e., pitches heard together can blend seamlessly or provoke acoustical tension. Likewise, in color relationships, we should accept the full range of harmonic possibility because at times visual tension can be a useful formal tool.

When considering color relationships, try to transcend ideas you may have about fashion and good taste. An acceptance of both concordance and discordance will help you tailor your color effectively to its purpose in your work. There is no universal standard for "good color." Color relationships work when they match the purpose they are intended to serve.

When colors share visual qualities, we perceive them as interdependent and unified. Conversely, the less they have in common, the more they assert their independence and appear disunified. Unity suggests tranquility and agreement. Disunity can evoke tension.

In figure 7.1 a yellow-green is seen against a blue-green. These two hues, analogous on the color wheel, have much in common. In this case they are also similar in value and saturation. These two colors are very much in agreement with each other.

In figure 7.2 the same yellow-green is seen against its complement, red-violet. The polarity of complements makes for the greatest possible contrast between two hues and there is considerable tension in this pair of colors. The disunity we see in this example might be troublesome in a wallpaper design, but appropriate in a painting where disjointed color relationships suit the painting's expression.

7.1 Colors in agreement: yellow-green against an analogous color, blue-green.

7.2 Colors in discord: yellow-green seen against its complement, red-violet. Each color competes for dominance.

Contrast in saturation and value are also important factors in COLOR HARMONY. In figure 7.3 a pale yellow square of subtle intensity is set against a dark, prismatic version of its complement, violet. When colors are unalike in all three color attributes, the contrast between them can be stark. But here the tension is softened by the hierarchical relationship between the two colors: the deep, rich purple dominates the lighter, weaker color so they don't compete for attention as in the previous example.

When colors are closely matched in all three attributes, they bind together. In figure 7.4 two muted colors (red-orange and yellow-orange) that are close in hue and value create a tightly unified visual field.

All nine colors in figure 7.5 are greenish chromatic gray, and hover around the upper-middle part of the value scale. In this case, minimal contrast creates a very quiet cohesion. Try to imagine an application for such a placid group of colors.

A more energetic example is figure 7.6, which is comprised of nine colors that are unified in value and saturation, but come from all parts of the color wheel. Diversity of hue and the overall intensity of the colors make this group clearly livelier than that in 7.5.

The arrangement in figure 7.7 coheres in hue and saturation, but its broad range of values from very light to very dark lends it some energy.

Figure 7.8 shows a color grouping that is unified in all but saturation. Its tension is subtle and quietly asserts itself.

Figure 7.9 is unified in value but not hue or saturation. This combination is discordant, but the close values hold it together.

Finally, figure 7.10 shows a combination of colors that are unalike in every category. This grouping has a kind of boisterous vitality.

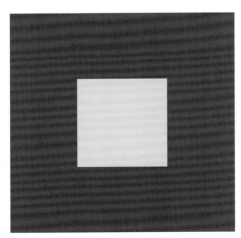

7.3 Two starkly different colors: one strong and one weak.

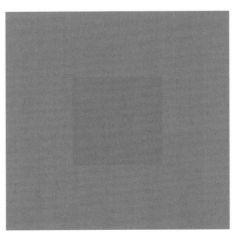

7.4 Low contrast in hue, value, and saturation makes for tight unity.

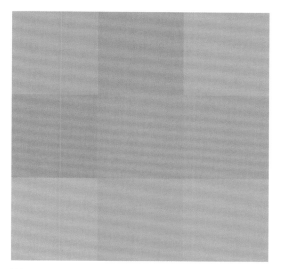

7.5 Nine colors unified in hue, value, and saturation. A quiet combination redolent of nature.

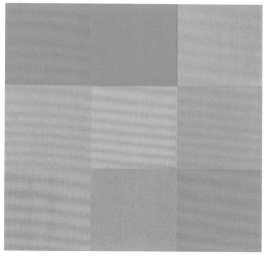

7.6 Nine colors unified in value and saturation but with contrasting hues.

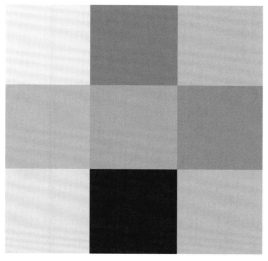

7.7 Nine colors unified in hue and saturation but with contrasting value.

7.8 Nine colors unified in hue and value but with contrast in saturation.

7.9 Nine colors unified only in value with contrast in both hue and saturation.

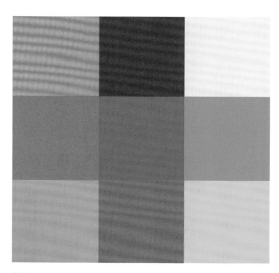

7.10 Nine colors that are disparate in hue, value, and saturation.

Bridge Tones

The contrast between two very different colors can be softened by the presence of BRIDGE TONES, which are intermediary tones containing attributes of both colors. Bridge tones provide transitions when placed between or near contrasting colors.

In figure 7.11 a prismatic scarlet is paired with a muted blue-green of a much lighter value. In figure 7.12 the same two colors are bridged by three tones that smooth the transition from the red to the blue-green.

The grid in figure 7.13 is composed of the original red and blue-green plus 14 bridge tones arranged alternately by hue as in a chessboard. Although there are points of contrast, the overall grouping is cohesive. The many bridge tones provide visual transitions that soften the differences between the two original colors.

Figure 7.14 shows the same colors arranged in a progressive sequence, moving from reds and reddish tones at the bottom of the grid up to greenish tones in the upper half. With the bridge tones organized in this manner, the contrast between red and green is almost eliminated.

 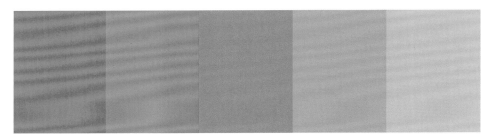

7.11 Two colors that differ greatly in hue, value, and saturation.

7.12 The same two colors "bridged" by progressive tones.

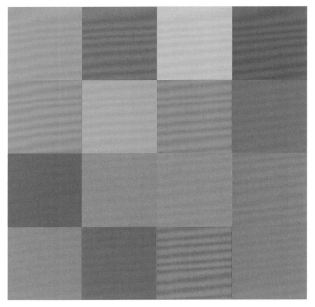 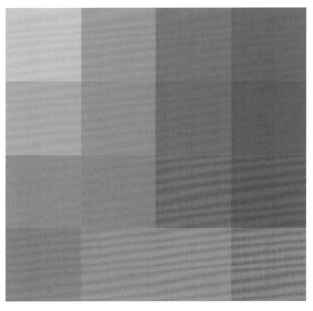

7.13 The same two colors among 14 tonal variations.

7.14 The colors from 7.13 rearranged to soften their contrasting characteristics.

Scan here for video demonstration.

TWO MIXING STRATEGIES TO PRODUCE UNIFIED COLOR

We are about to experiment with two methods of generating cohesion through color mixing. The first is based on tones derived from strictly limited source colors and the second involves altering a group of colors through a single common admixture. Assignments 10, 11, and 12 explore these strategies.

These assignments all require the mixing of paint for which there is no digital equivalent, so there is no digital follow-up in this chapter.

7.15A A neutral, mid-tone background made by intermixing red, green, and white.

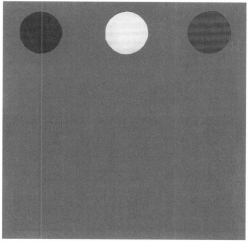

7.15B The same background with the original palette colors at the top: green, white, and red.

HANDMADE ASSIGNMENT 10: INTERMIXED DOT INVENTORY

Rationale: The studies you will be making for this assignment will reveal the surprising tonal potential inherent in a limited palette of only two colors.

10A. Using a Complementary Pair

Begin by putting a pair of prismatic complementary colors on your palette along with a mound of white. You can choose any two complements including tertiary hues, e.g., red-violet and yellow-green.

Combine your two complements and white to mix a mid-value, dull chromatic gray for a background that is roughly 30 square inches (76.2 sq. cm). Figure 7.15A shows a finished background made by intermixing the complements red and green.

Paint a swatch of each of the two prismatic complements and white on marker paper. When dry, cut them into three small circles (or squares) and glue them down at the top of your background as shown in figure 7.15B.

Then, create a series of 12 different tones by intermixing the two complements and white (the darkest tones will have no white in them). Paint swatches of each tone on marker paper. Cut into small circles or squares and glue them to your background color. Make three rows of tones consisting of four light, four middle and four dark values as in figure 7.15C. Any pair of complements will work for this study.

10B. Designing with Intermixed Complements

Create a design using the tones you made in Assignment 10A. A design or painting that exclusively uses tones from an intermixed pair of complements will have a cohesive overall light because the colors you generate automatically create bridge tones that link the complements. Figure 7.16 shows a design using the 12 tones from the previous dot inventory plus the two original prismatic complements.

The same limited palette of a complementary pair can be explored in a more painterly way as in figure 7.17. You may like to try this approach, where the intermixed colors are painted directly on the background somewhat gesturally.

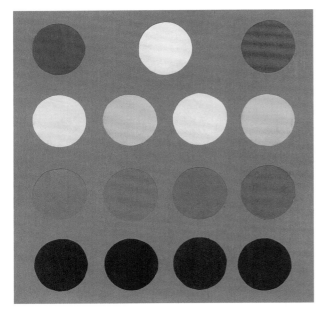

7.15C An inventory of tones made by mixing the same complements and arranged by value. Jenna Ventura.

7.16 A design that uses the tones in the previous example. Jenna Ventura.

7.17 A painterly exploration of the same palette.

7.18 An intermixed dot inventory made with ultramarine blue, alizarin crimson, and yellow deep.

7.19 An intermixed dot inventory made with phthalo blue, scarlet, and yellow light.

HANDMADE ASSIGNMENT 11: INTERMIXED DOT INVENTORY USING THREE DIFFERENT PRIMARY TRIADS

Rationale: This assignment explores the tonal range of three different primary triads. The inherent limitations of each triad manifest themselves in these studies to create three distinct light characteristics.

11A. Primary Triad 1: Ultramarine Blue, Alizarin Crimson, and Yellow Deep

The palette for the first study is made from a primary triad of *ultramarine blue, alizarin crimson, and yellow deep (plus white)*. Using all three primaries and white, mix a mid-tone, dull chromatic gray for a background that is roughly 30 square inches (76.2 sq. cm). Next, as in Assignment 10, paint a small swatch of each of your prismatic primaries plus white on marker paper. Then, using combinations of two or three of these primaries, make 18 different tones, six light, six mid-value and six dark, and paint them in small swatches on marker paper. *Try to make tones of each of the primary and secondary triads.* Cut all the swatches into small circles or squares, place the prismatic primaries at the top of your study and below them make three rows of six tones each, as shown in figure 7.18.

11B. Primary Triad 2: Phthalo Blue, Scarlet, and Yellow Light

The palette for this study is *phthalo blue, scarlet, and yellow light (plus white)*. As in Assignment 11A, use these colors to mix a mid-tone, dull chromatic gray for a background.

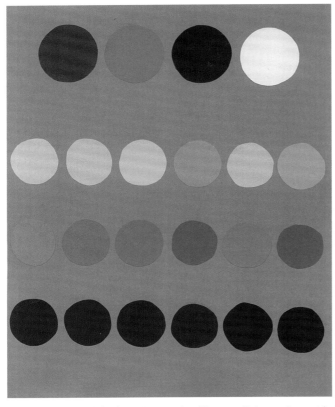

7.20 An intermixed dot inventory made with an earth tone primary triad.

Then make swatches of the three primaries and white. As in 11A, make 18 different tones, six light, six mid-value and six dark. Again, place the prismatic primaries at the top of your study and make three rows of tones as in figure 7.19.

11C. Primary Triad 3: Payne's Gray, Burnt Sienna, and Yellow Oxide
The third primary triad is composed of three earth tones: *Payne's gray* (or a bluish chromatic gray made by mixing ultramarine blue and burnt umber), *burnt sienna* (for red), *and yellow oxide (plus white)*. As before, make a mid-tone dull chromatic gray background by intermixing all these colors. The rest of the study follows the same pattern as Assignments 11A and 11B. See figure 7.20.

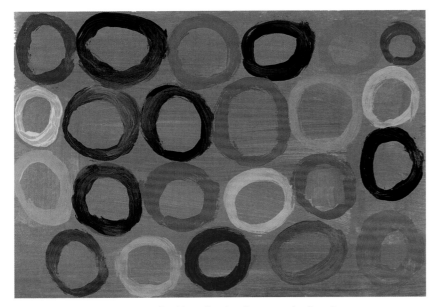

7.21 Painterly study of ultramarine blue, alizarin crimson, and yellow deep.

Fields of Light

In Part One we discussed how different kinds of artificial and natural light amplify certain parts of the color spectrum while dulling others. Recall that incandescent light enriches warmer colors while dulling cool ones. Fluorescent light does the opposite, vivifying cool hues while dulling warm ones. In a similar way, each of the three intermixed dot inventories from Assignment 11 emits a distinct overall quality of light that, as with artificial illumination, creates a unifying "field of light" by virtue of its limitations.

Each primary triad in our assignments favors some hues over others. This temperature bias is expressed in every tone derived through intermixing. For example, the combination of ultramarine blue, alizarin crimson, and yellow deep seen in the painterly study in figure 7.21 produces dull greens, muted oranges, and relatively vivid violets. Those limitations are felt throughout every tone made with this primary triad and give it its character.

Likewise, the limitations of the second triad, shown in figure 7.22, create their own specific light. Phthalo blue, scarlet, and yellow light produce dull violets, prismatic greens, and muted oranges.

The earth tone primary triad seen in figure 7.23 contains no prismatic hues and therefore cannot produce any prismatic secondaries. Its most saturated tones are dull muted colors (burnt sienna and yellow oxide) as they come straight from the tube. This limitation, as in the others, constrains its tonal possibilities definitively.

Bear in mind that in Assignment 11 we are only examining three of eight different combinations among the six co-primaries. You might experiment with any of the other five in the same way. Or substitute an earth tone for one or two of the primary colors in a prismatic primary triad; e.g., a combination of ultramarine blue, alizarin crimson, and yellow oxide.

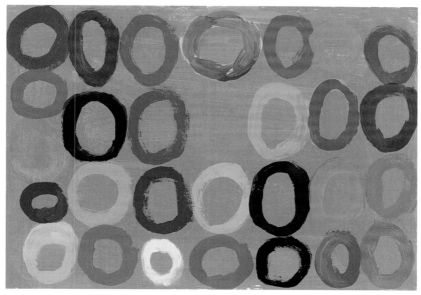

7.22 Painterly study of phthalo blue, scarlet, and yellow light.

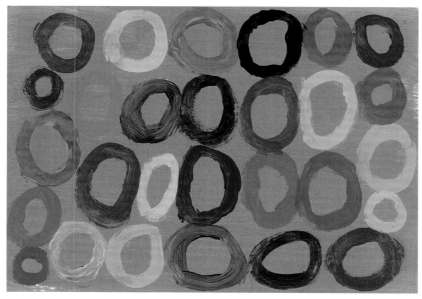

7.23 Painterly study of the earth tone primary triad.

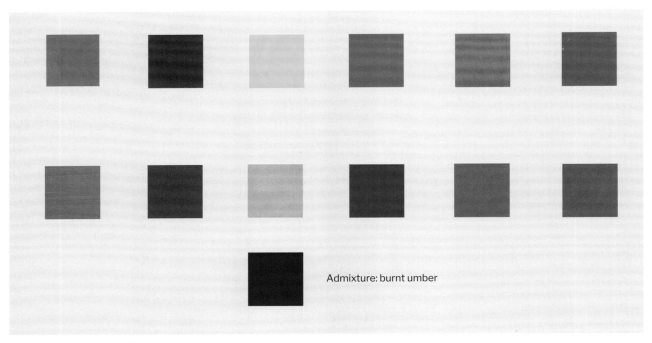

Admixture: burnt umber

7.24 Colors altered with an admixture of burnt umber.

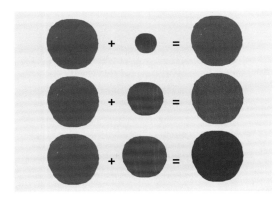

7.25 Three admixtures of burnt sienna to green in differing proportions.

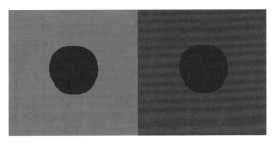

7.26 The third admixture from 7.25 looking red on the left and green on the right.

An Altered Palette

Another way to create cohesion among a group of diverse colors is by altering each color on the palette with a small amount of an "outside" color. Any group of disparate colors can be pulled together in this manner.

In figure 7.24 the six diverse, highly saturated colors across the top appear in a parallel row underneath altered by the addition of a quantity of burnt umber. Earth tones, particularly umbers, work well as unifying admixtures because they are low in saturation. Indeed, any dull chromatic gray will have a similarly consolidating effect.

Of course, the amount of the admixture will affect the value and saturation of the resulting color. In figure 7.25 the green on the left has been mixed with three different quantities of burnt sienna. Notice that the largest amount of admixture has produced a color of nebulous hue that might read as green or red depending on the context, as shown in figure 7.26.

7.27 Design with unaltered colors from 7.24.

7.28 Design with altered colors from 7.24.

HANDMADE ASSIGNMENT 12: COMPOSITION WITH AN ALTERED PALETTE

Rationale: In this assignment you will explore how the addition of a common admixture can pull together a disparate palette.

12A. Creating an Altered Palette

Create a color chart that demonstrates the effect of a single admixture upon a group of colors, as in figure 7.24. Begin by putting six prismatic colors on your palette, with two separate mounds of paint for each color. Then alter one set of colors with an admixture of an earth tone or a dull chromatic gray. Pay careful attention to the quantity of the admixture; take care to alter the original color without losing its hue identity. Make swatches of each set of colors (12 in all) on marker paper. (Make the swatches large enough to have enough left for Assignments 12B and 12C.)

On a piece of card stock, glue ½ x ½ inch (1.3 x 1.3 cm) squares of the six original unadjusted colors. Directly underneath those colors glue a second row of the altered tones. Then, as in figure 7.24, add a square of the admixture you used below the two rows. This color chart should not exceed 7 inches (17.8 cm) in width.

12B. Making a Design with Original Colors

On a rectangle or square of no more than 36 square inches (91.4 sq. cm) use color from the swatches of the original colors from Assignment 12A to create a simple, six-color design, as in figure 7.27.

12C. Making a Design with Altered Colors

Recreate the same design made in Assignment 12B, this time using the altered set of colors, as in figure 7.28.

Notice that the tempered colors in Assignment 12C are more cohesive than those in 12B because they all share the influence of one admixture: burnt umber.

7.29 Gerri Spilka, *Encounter in the Golden Courtyard*, 2018, Procion MX dyes printed and painted on cotton, cotton and wool batting, machine quilted. Private Collection.

7.30 Color summary of 7.29.

Intermixing and Color Schemes

Color schemes, such as those we examined in Part Five, limit hue choice while allowing for any tones that belong to the scheme. They are especially useful in graphic design applications that employ flat color or when constructing color with pre-made color elements as in collage or textile construction.

Intermixing strategies create unity by integrating color through physical intermixing or the super-imposition of translucent color. Once the palette is established, the unity of resulting mixtures is guaranteed. This approach to color harmony is common in painting and surface design.

Three Examples of Color Harmony

The color in Gerri Spilka's stitched textile (fig. 7.29) is integrated through a process of overlaying colored dyes, with the darkest colors built up and laid in last. As with watercolor, the lighter colors are the result of adding more water to the dye: no white pigment is used. This piece is basically made up of greens and yellows with very small areas of red-violet. The red-violet notes stand out against the yellow and green tonalities to create visual accents in an otherwise unified, analogous field of color. Figure 7.30 shows a nine-color summary of this textile.

In the painting shown in figure 7.31 Gwen Strahle has intermixed several pure, cool colors with earth tones to achieve a rich, integrated sense of light. The values hover around the middle of the scale and saturation is mostly held to chromatic grays and muted colors, with the purest tones concentrated in the blue-green shape at the center of the painting. The delicate precision of the color arrangement contrasts with brisk, tactile paint handling. Figure 7.32 shows a color summary of this painting.

A painting by Beth Livensperger (fig. 7.33) exemplifies the use of strong color contrast for expressive effect. The top half of the painting shares almost no color with the bottom half. The light of the dark, warm yellow sky is not reflected in the cool colors chosen for the building and its windows. At the bottom, prismatic magenta seethes beneath cool blue bricks. The disjointed color works in tandem with anomalies of scale and perspective to lend the image a disquieting atmosphere. The color summary in figure 7.34 has much the same unsettling quality as the painting.

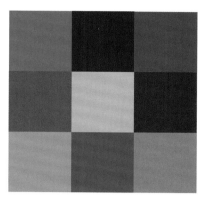

7.32 Color summary of 7.31.

7.31 Gwen Strahle, *Gem*, 2016, oil on canvas. Private Collection.

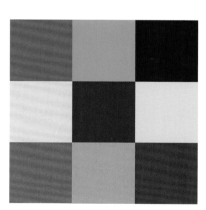

7.34 Color summary of 7.33.

7.33 Beth Livensperger, *You're Rich, We're Rich*, 2018, oil on canvas. Private Collection.

PART EIGHT APPLYING COLOR PRINCIPLES

IN PART EIGHT YOU WILL

→ Define tonal progression and demonstrate its visual qualities.

→ Comprehend the relationship between actual transparency and illusionistic transparency.

→ Illustrate both median and dark transparency.

→ Recognize how each color attribute contributes to the illusion of space on a two-dimensional surface.

It is well to remember that a picture, before being a battle horse, a nude woman, or some anecdote, is essentially a plane surface covered with colors assembled in a certain order.—Maurice Denis

8.1 William Itter, *Winter: Fringed Chart*, 1985, oil on linen. Collection of William

The work you have done so far has prepared you for more challenging studies that will strengthen your grasp of fundamental color principles by applying them to specifically defined goals. Tonal progressions and the illusion of transparency require precise color mixing and will deepen your understanding of color while introducing concepts and strategies that can be applied to two-dimensional art and design.

TONAL PROGRESSION

When a series of tones shift gradually in discrete, controlled steps, we call it a tonal progression. A related color technique, tonal gradation, is also based on color transition, but gradations occur smoothly without seams or joints.

A good example of tonal gradation can be seen in a painting by William Itter titled *Winter: Fringed Chart* (fig. 8.1). Throughout this painting colors blend into each other, their numerous shifts evoking an overall sense of movement and uncertainty.

8.2 Nancy Crow, *Crosses*, 1976, pieced and quilted cotton. International Quilt Study Center & Museum, University of Nebraska-Lincoln.

In contrast, Nancy Crow uses tonal progression in her quilt *Crosses* (fig. 8.2). By precisely choosing her colors and organizing them in sequential increments, she animates a symmetrical pattern with flux and spatial layering. Unlike tonal gradation, tonal progressions offer a dual reading: you are simultaneously aware of both the sweep of transition and the individual tonal increments that comprise it.

The tonal progression with which we are most familiar is the standard grayscale. Grayscales typically consist of ten or eleven evenly spaced shades that run from black to white. As you have seen, the grayscale is a practical tool, but it demonstrates a progression in value only.

More intriguing progressions can be based on combinations of color attributes or confined to a limited range within a larger gamut of tones to create subtle, seductive effects.

Three examples of such focused five-step progressions are shown in figures 8.3, 8.4, and 8.5.

Tonal progressions can occur in any number of steps. Figures 8.6, 8.7, and 8.8 show several constrained ten-step progressions.

8.3 A five-step progression in hue from blue-violet to red-violet (no progression in value or saturation).

8.4 A five-step progression in hue and saturation from a muted red to a chromatic gray yellow (no progression in value).

8.5 A five-step progression in hue from blue to green (no progression in value or saturation).

8.6 A ten-step progression in hue, from green to red, and in saturation, with the dullest tones in the center.

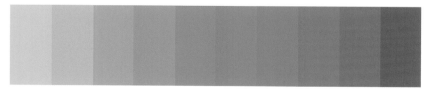

8.7 A ten-step progression from light to dark and from yellow to green.

8.8 A ten-step progression in hue (from blue to yellow-green), saturation (from prismatic to chromatic gray), and value (from dark to mid-tone).

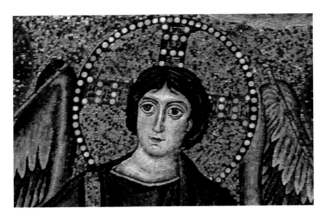

8.9 Maker unknown, detail of 6th-century mosaic, Church of San Vitale, Ravenna.

Tonal Progression in the Service of Form

In traditional decorative arts (e.g., tapestries, rugs, and mosaics), particles of flat tone are often arranged as progressions to depict volumetric forms and the play of light across their surfaces. A detail of a mosaic at Ravenna illustrates how pieces of colored glass can be organized to depict light striking a rounded form (fig. 8.9).

Tonal progressions are sometimes used in painting. Instead of blending colors to create the illusion of form in his still-life painting, Euan Uglow built volume by applying carefully modulated patches of color with a palette knife (fig. 8.10).

8.10 Euan Uglow, *New Discovery*, 1992, oil on board. Collection of Elaine and Melvin Merians.

Interspersing Color Progressions

Two distinct tonal progressions can be integrated to create a compelling visual effect. The two progressions shown in figures 8.11A and B are quite different. With little transition in value, 8.11A has the same prismatic red at each end, with saturation diminishing in steps toward the middle. In 8.11B, values shift from dark to light in the manner of a traditional grayscale, but it also features a dramatic hue transition, moving from violet to yellow in ten increments.

The two progressions are merged in figure 8.12, revealing dramatic incidents of color interaction, especially in the reds, which appear to go through changes in hue, value, and saturation as you pan the image from top to bottom.

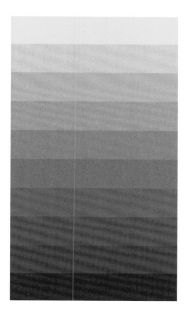

8.11A, B Two distinct tonal progressions.

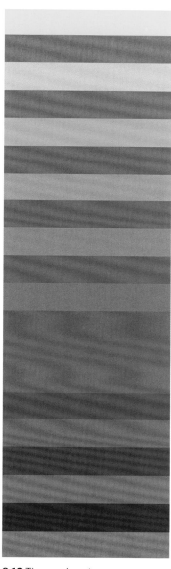

8.12 The previous two progressions interspersed.

HANDMADE ASSIGNMENT 13: TONAL PROGRESSION STUDIES

Rationale: Painting and assembling tonal progressions will sharpen your understanding of color structure while refining color-mixing skills. By considering hue, value, and saturation when conceiving these studies, you can create beautifully controlled color effects.

13A. Creating Tonal Progressions

Make two subtle five-step tonal progressions from swatches painted on marker paper and pasted on card stock. Make each swatch 1 x 5 inches (2.5 x 12.7 cm). From these you can cut ½ x 4 inch (1.3 x 10.2 cm) strips to compose progression sequences. Each of the two sequences should be based on a different premise. For example, one might shift in hue and value but not saturation, while the other might change in saturation and hue but not in value. (Look again at figures 8.3–5 for examples of focused five-step progressions.)

13B. Combining Tonal Progressions

After you have arranged the two progressions on the left side of the page, combine them in an alternating sequence to create a counter movement and place the integrated progressions to the right of the other two. The diagram in figure 8.13 demonstrates how you should lay out the three parts of this study. Figure 8.14 shows a finished study.

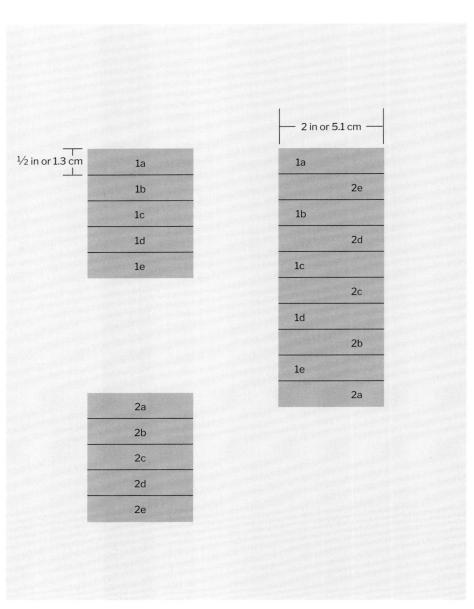

8.13 Guide for laying out Assignment 13.

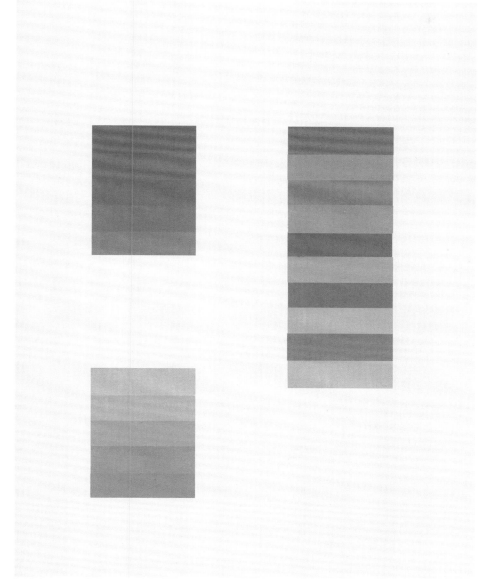

DIGITAL ASSIGNMENT 9: TONAL PROGRESSION STUDIES

When creating tonal progressions, think about the movement of the sliders in terms of quantities of hue, value, and saturation. Get a rough transition down between the tones and then go back and adjust them. Lay the project out using the template shown in figure 8.13.

8.14 Assignment 13. Josh Meir.

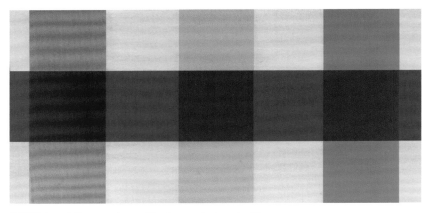

8.15 Colored films overlapped to demonstrate actual transparency.

8.16 Molly Heron, *Mo. 3.15*, 2015, acrylic on paper. Collection of Caroline Boynton.

THE ILLUSION OF COLOR TRANSPARENCY

Overlapping colored tissue papers, thin textiles, or acetate gels all provide an actual experience of transparency. This phenomenon is a regular technical feature of watercolor painting, glazing in oil paint, and four-color printing. Figure 8.15 shows strips of colored film overlapping each other. The tone you see where the colors overlap combines the hues of the two parent colors. Notice that the color at the intersection is also darker in value than either parent color.

Actual transparency is not illusionistic but rather a directly observable optical event. Figure 8.16 shows a painting composed of thin veils of overlapping color that makes use of actual transparency. Transparent colors are characteristically lucid because light passes through the paint film, strikes the underlying surface, and then travels back through the color to the eye. It's as if the color is lit from behind as in a stained-glass window.

The illusion of transparency occurs when two or more colors appear to overlap because the color at the intersection has been precisely mixed to simulate actual transparency. It is often seen in woven and constructed textiles, as in the exquisite hand-weaving of Richard Landis shown in figure 8.17.

There are two distinct kinds of transparency illusion that are useful in design applications: median transparency and dark transparency.

8.17 Designed and woven by Richard Landis; Co-Designed by Craig Fuller, *Nucleus*, 1976, textile, cotton double cloth. New York, Cooper-Hewitt – Smithsonian Design Museum.

(Dark transparency is sometimes referred to as "film" transparency because it imitates the superimposition of overlapped translucent colored films, as seen in figure 8.15.)

In MEDIAN TRANSPARENCY, the hue and value of the overlapping area at the center of the cross (fig. 8.18) lies precisely halfway between the hue and value of the two parent colors in the wings of the cross. In the illustration, a light yellow appears to move across blue, and the square in the center is a median value between those of the yellow and blue. The hue of the central square is blue-green, halfway between light yellow and blue on the spectrum.

To ascertain that the median tone at the "overlap" is precisely centered between the two parent hues, isolate each wing of the cross as in figure 8.19. Notice that the center color looks blue-green against the yellow wing and yellow-green against the blue.

DARK TRANSPARENCY is so called because the value of the color at the intersection is darker than that of both parents. For example, when a dull orange and a sky blue appear to overlap as in figure 8.20, the square at the intersection is darker than both the orange and the blue. As with median transparency, the color at the center of the cross should evenly combine the hue of both parent colors, as in figure 8.21.

8.18 Illusion of transparency: median transparency.

8.19 Isolating the wings of a median transparency cross reveals the color at the intersection is centered in both hue and value.

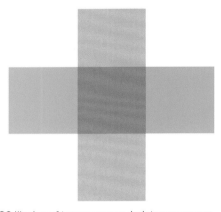

8.20 Illusion of transparency: dark transparency.

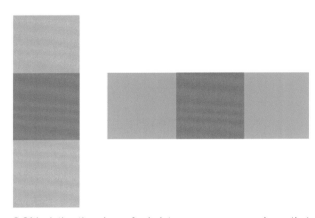

8.21 Isolating the wings of a dark transparency cross shows that the color at the intersection is centered in both hue and value.

8.22 Plaid design incorporating the illusion of transparency.

The illusion of transparency creates the appearance of layered space on a two-dimensional surface. This design (figure 8.22) was inspired by madras plaid and Scottish tartan. The design of woven plaids is based upon grid structures that seem to be composed of overlapping translucent strips of color.

Scan here for video demonstration.

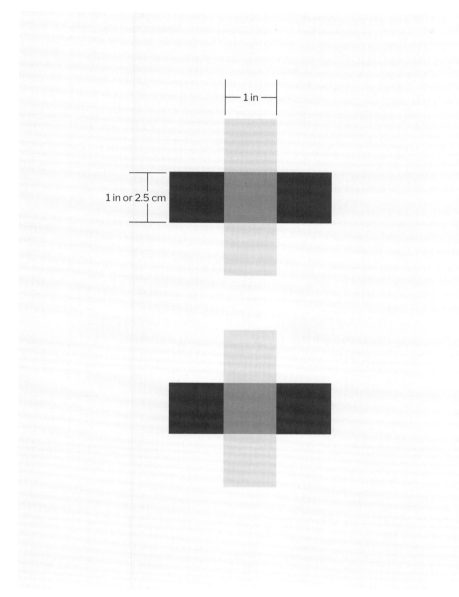

8.23 Guide for laying out Assignment 14.

HANDMADE ASSIGNMENT 14: ILLUSIONISTIC TRANSPARENCY

Rationale: Transparency studies, like progression studies, emphasize color interaction within a practical context. They demand precise color mixing and fortify understanding of the interrelationships between hue, value, and saturation.

The diagram in figure 8.23 shows how to lay out this assignment.

14A. Median Transparency
Make two transparency crosses that demonstrate median transparency as in figure 8.24. Note that median transparencies work best when the two parent colors are diverse in value. If the parents are similar in value, it becomes difficult to find a median that is clearly visible. Try to use hues that are somewhat separated from each other on the color wheel. Also, consider the challenge of using different levels of saturation in each study.

14B. Dark Transparency
Make two transparency crosses to show dark transparency as in figure 8.25.

Dark transparencies look best when the two parent colors are similar in value. Again, pick hues that are not near each other on the color wheel and use a variety of saturation levels.

Note: Neither median nor dark transparencies read clearly when the two parent colors are dark.

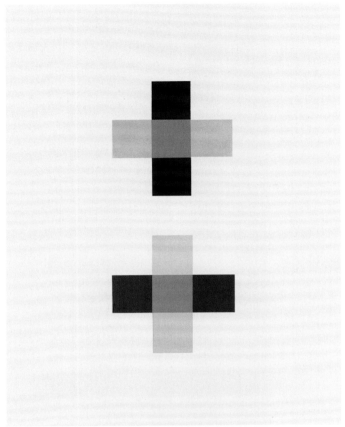

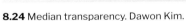

8.24 Median transparency. Dawon Kim.

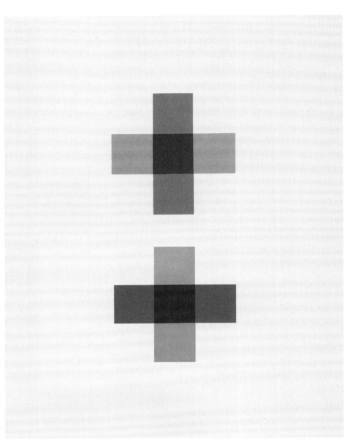

8.25 Dark transparency. Dawon Kim.

COLOR AND THE ILLUSION OF SPATIAL DEPTH

It is well known that color can contribute to the illusion of spatial depth in a two-dimensional image or design. This is usually explained in terms of each color attribute: hue, value, and saturation.

Hue: Warmer colors advance, cooler colors recede.

In figure 8.26 a warm color is flanked by two colors that get progressively cooler as they move away from the center. All three are equal in saturation (bright muted colors) and value (around mid-tone). There are no linear signifiers such as overlap, size variation, or perspective to influence the spatial hierarchy, so hue is the only active agent in this example. Yellow-orange at the center seems to advance while its neighboring colors recede.

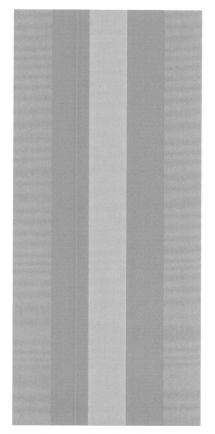

8.26 Warmest color advancing.

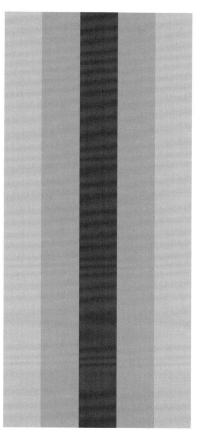

8.27 Darkest color advancing and receding.

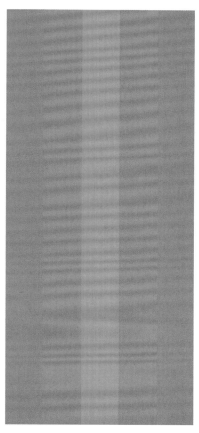

8.28 Purest, most saturated color advancing.

Value: Darker colors advance, lighter colors recede.

Figure 8.27 shows three colors unalike in value, but similar in hue and saturation. The dark color at the center does seem to dominate the visual field, but you can also flip the figure-ground relationship in your mind and see the dark center color as dropping back behind two lighter panels. This suggests that value may be a more equivocal spatial indicator than hue or saturation.

Saturation: Purer colors advance, duller colors recede.

Figure 8.28 shows three colors that are disparate in saturation, but similar in hue and value. The center color, a prismatic red, appears to advance in relation to its neighbors.

All three of these assertions are true under the right circumstances. But, as often happens, when a color is light in value (receding) and warm in temperature (advancing), or warm in hue (advancing) and dull in saturation (receding), these "rules" come into conflict with each other. Moreover, although these general observations hold true under hothouse conditions like those shown in the last three illustrations, color is seldom seen in such isolation. Linear devices, e.g., overlapping shape, relative size, and formal and informal linear perspective, also create the illusion of space independent of color. Color, when applied, may agree with or contradict one or more of these other spatial signifiers.

8.29A Line drawing showing how size and overlapping shapes create the illusion of depth.

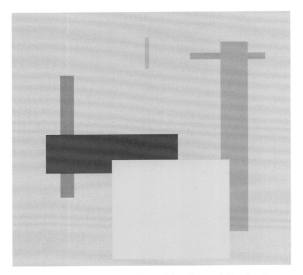

8.29B The same configuration with colors reinforcing the spatial illusion.

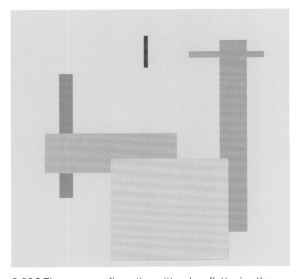

8.29C The same configuration with colors flattening the spatial illusion.

In a line drawing (fig. 8.29A), six rectangles appear to hover at varying distances from the viewer's eye. As shapes seem to overlap and get smaller, they push back into space.

Figures 8.29B and C show the same configuration in full color. In 8.29B, color is in spatial agreement with line. The warmest, brightest shape (the yellow rectangle) is also the largest. It overlaps any rectangle near it. Likewise, the coolest, dullest colors fill both the background and the two smallest rectangles. The color in 8.29C reverses that of 8.29B, putting the brightest, warmest color in the background while placing a light, cool chromatic gray in front.

Consider the spatial differences between these two renderings in terms of relative overall flatness. Where color and line agree as in 8.29B, the representation of three-dimensional space is persuasive. It is easy to perceive the large yellow rectangle at the bottom and the small, vertical rectangle at the top as being separated by a vast distance.

Spatial tension results when color and line disagree, as in figure 8.29C. This is what the Modernist painter and educator Hans Hofman called "push pull." Despite their great size differential, the large gray rectangle at the bottom and the thin, vertical rectangle at the top seem to occupy the same foreground plane. Here, the spatial logic of the color runs counter to that of line to make a much flatter image.

Traditional Western landscape painting requires a convincing depiction of deep space, as shown in a nineteenth-century painting by George Inness (fig. 8.30). Here color consistently serves spatial illusion. A small patch of red (the only prismatic color in the entire painting) enlivens the foreground. That red, along with a rich russet orange and a few stark whites, helps establish nearness. As you look between the trees and into the distance, the colors diminish in saturation while the subject matter shrinks in scale. Finally, the far distant hills are rendered in cool light tones of chromatic gray. The picture plane itself becomes invisible and the painting, a window into a world.

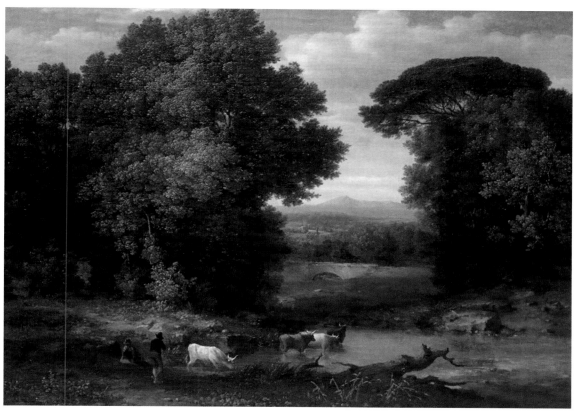

8.30 George Inness, *A Bit of the Roman Aqueduct*, 1852, oil on canvas. High Museum of Art, Atlanta, GA.

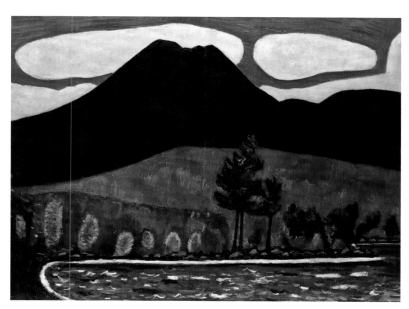

8.31 Marsden Hartley, *Mt. Katahdin, Autumn, No. 2*, 1939–40, oil on canvas. Metropolitan Museum of Art, New York.

Contrast this with Marsden Hartley's painting from 1939 (fig. 8.31). Here the emphasis is on immediacy and a dualistic concept of picture making that places equal stress on the subject matter (Mt. Katahdin) and the psychological impact of raw color and shape. It's impossible to look deeply into this painting. Color is not arranged to foster an illusion, but rather to announce itself directly to the viewer's nervous system.

While the properties of hue, value, and saturation can be applied to create the illusion of space on a two-dimensional surface, the relationship between color and space is often complicated by circumstance. The relational nature of color, the influence of line and shape, and physical phenomena such as translucency and texture interact in ways that demand attention.

PART NINE COLOR RESEARCH

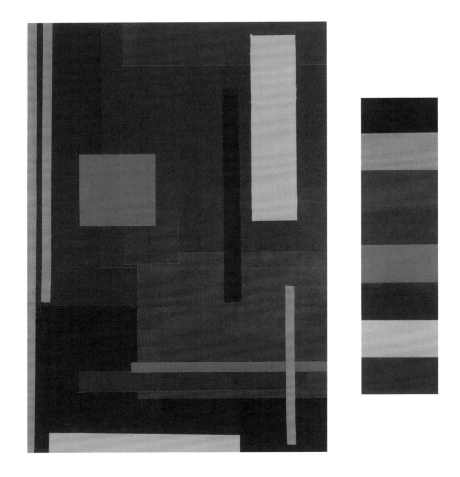

IN PART NINE YOU WILL

→ Identify source material for color exploration.

→ Summarize color content proportionally and nonproportionally.

→ Demonstrate color-matching skill.

→ Create designs using color from outside sources.

Color exists in itself, possesses its own beauty. It was Japanese prints that we bought for a few *sous* on the rue de Seine that revealed this to us.—Henri Matisse

SOURCES OF COLOR

Even an experienced artist can fall into habits and formulas and need refreshment from outside sources. Henri Matisse, for example, made a lifelong study of color in the decorative arts of Eastern cultures. Paul Klee collected and studied the paintings of children and Vincent van Gogh reputedly spent evenings by lamplight arranging bits of colored yarn on a gray piece of cardboard in order to experience colors in interaction with each other.

You too can begin to identify natural or manmade color samples that attract and inspire you. Such things as seashells, stones, leaves, paper wrappers, faded wallpaper, old bookcovers, or peeling paint can have great beauty. Flat art and design of any period is also a good source. In fact, almost anything that crosses your field of vision might stimulate your color thinking.

Collect color examples that intrigue you or use your cell phone camera to document samples that you can store in a digital file and peruse at leisure. To gain a better understanding of the color sources you admire, you can analyze them quantitatively in a PROPORTIONAL or NONPROPORTIONAL COLOR INVENTORY.

The Proportional Color Inventory

A proportional color inventory documents the colors from a discovered source in their proportional relationships. It is suited to images that have a countable number of flat, unmodulated colors. Woodcuts, wallpaper designs, many examples of Eastern art, package design, and modern paintings and illustrations done in a graphic style all lend themselves to proportional color analysis. (If you are doing Assignments 15 and 16 by hand, you can work from original objects or from photographs taken of them. If you are doing these assignments in Adobe Photoshop, source material should be scanned or photographed.)

The historic German banknote shown in figure 9.1 is a good candidate for a proportional color inventory. It has eight flat colors.

The best way to organize a proportional inventory is with strips of color stacked in a vertical rectangle. Figure 9.2 shows a proportional breakdown of the colors as they appear in the German bill.

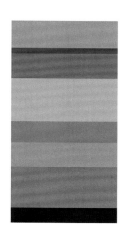

9.1 Source for a proportional color inventory.

9.2 Color found in 9.1 arranged proportionally.

Scan here for video demonstration.

9.3 Karen Schulz, ... *And The Skeptic*, fiber, 2016. Courtesy of the artist.

9.4 Proportional color inventory of 9.3. Ashley Sparacino.

HANDMADE ASSIGNMENT 15: A PROPORTIONAL COLOR INVENTORY

Rationale: Color inventories of source material take the color from its context and make it ready for use. A proportional inventory not only records color content, it details proportional color relationships. Taking color from an inventory to use in your own original design gives you an inside view of the palette you admire.

15A. Making a Proportional Inventory

Choose your source image with care. Make sure all the colors are flat and that they are countable. Match each color in your source and paint a swatch of that color on marker paper. Make enough of every color to do the inventory and a design based upon it (Assignment 15B).

The proportional inventory should not be large. Outer dimensions can be around 8 x 2 inches (20.3 x 5.1 cm). Try to estimate the precise proportions of the color in your image and then cut and paste each color bar in a vertical column on card stock. Figures 9.3 and 9.4 show a source image and a proportional color inventory derived from it.

15B. Design Study

Make a study using the colors from your inventory with the same proportions as those found in the source image. Your composition should not exceed 36 square inches (91.4 sq. cm). Paste color from your swatches directly upon card stock. Figures 9.3–9.5 demonstrate these two assignments.

For an additional challenge, make a second study with the same colors in different proportions.

9.5 Design study based on the proportional color inventory in 9.4. Ashley Sparacino.

DIGITAL ASSIGNMENT 11: A PROPORTIONAL COLOR INVENTORY

11A. Making a Proportional Inventory
In Adobe Photoshop, you can simply use the "Eyedropper Tool" to select the colors in your source and construct your inventory directly. Concentrate on accurately representing the proportional distribution of color in the source.

11B. Design Study
Use the "Eyedropper Tool" to transfer the color from your source image to an original design.

9.6 Source for a nonproportional color inventory.

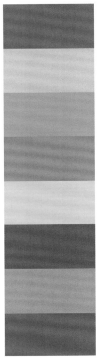

9.7 Color found in 9.6 summarized in eight even increments.

The Nonproportional Color Inventory

Natural and manufactured objects that have innumerable colors can also be a rich color source. But, because their colors are uncountable, a proportional color inventory is not possible. The best way to assess the color in this situation is with a nonproportional color inventory. Here, the goal is not to record all the colors you see, but to summarize them in a limited number of tones that represent, as well as possible, their full range. As with the proportional inventory the colors are arranged in a column of strips, but here the increments are of equal size.

Figure 9.6 shows an autumn leaf whose colors are too numerous to count. The column of colors in figure 9.7 summarizes those of the leaf in equal increments.

Nonproportional inventories can be surprising. When you begin to extract specific colors from a complex color field, they can take on an unanticipated strength and singularity. It is an efficient way to produce a useful palette that will carry you beyond your habitual color choices.

Natural objects, in particular, tend to yield groups of colors that cohere beautifully. Whether they are used exclusively or in combination with additional colors, a palette derived from a nonproportional inventory can expand your color repertoire.

9.8 Bookcover used as a source for a nonproportional color inventory.

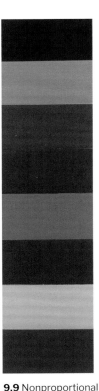

9.9 Nonproportional color inventory of 9.8. Catherine Falco.

HANDMADE ASSIGNMENT 16:
A NONPROPORTIONAL COLOR INVENTORY

Rationale: Assignment 16 provides a second strategy for the evaluation of color from a source whose color is too complex to assess proportionally. The follow-up study gives you an opportunity to apply the colors of the inventory in an original design.

16A. Making a Nonproportional Inventory

Working from a color reproduction of an object with an *uncountable* number of tones, make an eight-tone summary of the colors you find there. (In a nonproportional inventory, the number of samples is flexible; later you might try expanding that number for a fuller assessment of a color source.) As well as you can, represent the overall color character of your source. Begin by matching the extremes of color in the source: the lightest and darkest and the dullest and most pure. In your remaining four samples, try to characterize the full range of hue, value, and saturation you are seeing. Make the inventory 8 x 2 inches (20.3 x 5.1 cm).

Figures 9.8 and 9.9 show a timeworn bookcover as a source and a nonproportional inventory of its color content.

16B. Design Study

Using the same swatches you made for Assignment 16A, make a composition. The design should not exceed 36 square inches (91.4 sq. cm). For an example, see figure 9.10.

DIGITAL ASSIGNMENT 12:
A NONPROPORTIONAL COLOR INVENTORY

12A. Making a Nonproportional Inventory
As in Assignment 11, use the "Eyedropper Tool" in Photoshop to extract what you think are the eight most characteristic tones in your source material and make a column of those colors in even increments.

12B. Design Study
Use the "Eyedropper Tool" to transfer the same eight colors from your inventory to create an original design.

9.10 Design study based on the nonproportional color inventory in 9.9. Catherine Falco.

PART TEN COLOR EXPERIENCE & INTERPRETATION

IN PART TEN YOU WILL

→ Distinguish color symbolism from color analogy.

→ Recognize how hue, value, and saturation contribute to the interpretation of color.

→ Demonstrate color mood in an original design.

→ Discover how the description of color can reveal meaning in a work of art.

Pure colors... have in themselves, independently of the objects they serve to express, a significant action on the feelings of those who look at them.—Henri Matisse

COLOR AND MEANING

So far, we've discussed color primarily as a visual phenomenon, addressing its structure, its interactive nature, and ways in which it can be organized. But color has another essential dimension: the way it affects the psychology of the viewer. Intrinsic as it is, our response to color is complex, determined by both physical experience and cultural influence. It can also be idiosyncratic, especially when it comes to personal color preferences and associations. Therefore, generalities about what colors signify or how certain colors make us feel should be viewed with a degree of caution. With that caveat in mind, let's examine two major sources of shared color meaning, symbolism and analogy.

Color Symbolism

When a color is used to signify an abstract idea or represent a belief, it functions as a symbol. But connections between ideas and colors can differ or even be contradictory from time to time and place to place. Red, for example, can stand for love, passion, and lust but also signify danger or warning.

The associations responsible for COLOR SYMBOLISM sometimes originate in observation. But whatever their precise origins, color symbolism is culturally determined, a learned connection bound by time and place and not the result of direct color experience.

The colors we think represent abstract concepts are almost always prismatic and typically involve a single color. There are, however, instances of color combinations that have symbolic meanings. Certain holidays in North America are associated with symbolic color pairs: red and green with Christmas, orange and black with Halloween, and purple and yellow with Easter. Tricolor combinations linked with nationality are used in flags and commemorative decorations.

Color symbolism, while it does convey meaning, is a very limited tool because symbolic meaning is prepackaged and its conventionality invites cliché. In the hands of a clever artist, however, color symbolism can be invested with irony to forge new meanings by recontextualizing old ones.

One such artist is Barbara Kruger. Kruger creates large-scale works that juxtapose text and photography to comment upon contemporary cultural attitudes. Her images have an artless forcefulness that imbues her message with a sense of urgency.

Kruger's stark use of red and black brings to mind the propaganda poster art of both the Nazis and Bolshevists. But instead of proclaiming, "The Reich will never be destroyed if you are united and loyal," Kruger's text is typically more oblique, saying things like, "How dare you not be me?" or "I shop therefore I am" (fig. 10.1). She appropriates the look of the propaganda poster to make ironic points about social hypocrisy, consumerism, and gender politics.

Color Analogy

Unlike color symbolism, color analogy does not depend upon prefabricated association, but upon the direct experience of color as a visual phenomenon. It is felt, not thought. A good example is the warm/cool dichotomy represented in the two sides of the color wheel.

The equation of blue, green, and violet with coolness is probably rooted in elemental experiences such as ice, shadow, and deep water. Extrapolating from that, cool colors can evoke a sense of distance and even suggest solitude or indifference to emotion.

10.1 (opposite page) Barbara Kruger, *Untitled (I Shop Therefore I Am)*, 1987, print, Marciano Foundation. Courtesy of the artist and Sprüth Magers.

10.2A A prismatic red.

10.2B A duller version of the same red.

10.3 and 10.4 JoAnne Carson, *You Will See Marvels*, 2016, acrylic paint on canvas. Courtesy of the artist.

Conversely, red, orange, and yellow are naturally linked to the heat of the body, fire, and the sun. Warm colors evoke intimacy, anger, and sexuality. In general, warm hues tend to be associated with emotion and cool hues with reason.

But when we speak of color solely in terms of temperature, we are only taking hue into account. More nuanced color analogies are formed when colors are tonal and elude nomenclature.

Figures 10.2A and 10.2B are both red and of the same value, but they differ significantly in saturation. That's enough to differentiate their expressive characteristics. Let's try some comparative associations. If these two colors were sounds, which would seem louder? If they were tastes, which would be sweeter? If they were temperaments, which would be more resolute? If ages, which more youthful? The answer to all four questions is likely to be the prismatic red (fig. 10.2A) due to its brightness and clarity. The second, duller red has a time-worn quality and implies a sense of equivocality.

Values also carry common associations. If we imagine value in terms of sound, we tend to connect colors at the lighter end of the value scale with higher pitch. A squeak would be very light in value, a thud much darker. Dark colors seem heavier than light ones.

10.5 A bright group of hues.

10.6 The same hue arrangement as in 10.5, but with an admixture of raw umber and white.

10.7 Another version of the same hues highly tinted.

Associations that link the visual properties of color with non-visual experience make intuitive sense, but one should be wary of trying to direct a viewer's response too deliberately. When colors are combined, their individual characteristics become enmeshed in a larger whole that can provoke complex psychological reactions. Moreover, color is only one of the parts that go into making a work of art. When integrated with other formal elements, it can be difficult to separate its psychological impact from that of other factors.

In the painting shown in figure 10.3, JoAnne Carson uses line, shape, and stylistic distortion to ebullient effect. But much of the painting's character is carried by her use of color, which actively contrasts all three attributes. When only the value structure of the painting is visible (as in figure 10.4), much of its psychological impact is diminished.

The Psychological Effect of Color Relationships

Just as we link individual colors to our experience of the world, color groupings can also provoke associations. The overall psychological impact of a color group depends upon the interrelationships between all three color attributes. To illustrate this, let's examine a series of grids each consisting of nine colors. The grid format allows us to isolate the effect of color relationships without the distraction of other formal variables.

The first grid (fig. 10.5) consists of nine prismatic colors of diverse hue and broad contrast in value. This kind of palette is often associated with the artwork of children or folk art and often evokes joy and even innocence.

The grid in figure 10.6 uses the same hue arrangement and similar value relationships, but this time an admixture of raw umber and white has been added to each color, which makes for a much quieter, more cohesive ensemble of tones redolent of constraint or equivocation.

The grid in figure 10.7 uses the same hue arrangement again. This time the admixture is white alone and the result is a collection of luminous tints. This group of colors is light and airy.

10.8A A forceful arrangement of shapes.

10.8B Composition with forceful color.

10.8C Composition with quiescent color.

HANDMADE ASSIGNMENT 17: A DESIGN IN TWO MOODS

Rationale: By painting the same design twice in two very distinct color "moods," you will experience how color can contribute to an image's psychological effect.

17A. Creating an Expressive Design

Invent a simple linear design that, in itself, has a distinct mood or attitude. Next, using painted paper collage, apply color that you believe is in sympathy with the character of the design. For example, if your design feels agitated, make the color evoke agitation, etc.

17B. Contrasting the Mood

Make a second version of the same design using color that expresses a mood which contrasts with that of the design. These studies should not exceed 36 square inches (91.4 sq. cm).

Figure 10.8A shows a linear design that could be characterized as "forceful." All edges are diagonal and there are several points of visual tension. The overall effect is energetic.

The first color version of this study (fig. 10.8B) is composed of six colors that contrast sharply with each other in hue, value, and saturation. The color choices support the somewhat strident character of the design.

The second study (fig. 10.8C) is more passive. The brightest colors in 10.8B have been replaced with much duller and quieter versions of similar hues. The character of the color is in contrast with that of the composition, and, to a degree, tames it.

DIGITAL ASSIGNMENT 13: A DESIGN IN TWO MOODS

Assignments 17A and B can easily be explored in Photoshop. Because of this ease of execution, you might try doing several pairs to explore the psychological relationship between color and design.

10.9 Vincent van Gogh, *La Mousmé*, 1888, oil on canvas. National Gallery of Art, Washington, DC, Chester Dale Collection.

DESCRIBING COLOR

"I also have the portrait of a girl of 12, brown eyes, black hair and eyebrows, yellowish matte complexion. She sits in a cane chair, a blood-red and violet striped jacket, a deep blue skirt with orange dots, a branch of oleander in her hand. The background light green, almost white." Vincent van Gogh wrote this description of the painting shown in figure 10.9 to his sister Willemien on July 31, 1888.

The letters of Van Gogh are rich with careful attempts to describe the color of his paintings or the color of those subjects that inspired him. He mentions hue, of course, but also uses specifying adjectives that suggest value ("light green") or saturation ("deep blue"). He reaches for analogy in the term "blood-red" and refers to surface luster when alluding to a "yellowish matte complexion." The frequency of such color description in Van Gogh's letters confirms the importance he accorded color in his work.

Despite the limitations of language, the descriptive analysis of color in works of art can help sharpen your powers of observation and fortify your understanding of color structure. Truly, we tend to look more closely when we are compelled to describe something. Any colorful art object from any historical period or geographical location can provide an opportunity for verbal analysis.

In your descriptions, use the terminology and concepts you have encountered here, e.g., tint, shade, prismatic, muted color, chromatic gray, hue, value, color temperature, and saturation. Think about the color structure in the work you are examining along with other related factors, e.g., how the disposition of the color works to assert or deny the illusion of space. Try to assess how color specifically contributes to the overall experience of the piece.

Group critiques provide an excellent venue for careful description. In fact, describing what we see rivets our attention and lays a solid groundwork for more interpretive comments, tying form and content to the meaning and experience of a work of art.

10.10 Richmond Lewis, *Plumb*, 2012, egg tempera on linen mounted on panel. Collection of Rosie Newton.

10.11 Still from *Adventure Time*. Frederator Studios.

Four Color Descriptions

The color in Richmond Lewis's painting (fig. 10.10) is dominated by cool greens, blues, and violets with linear articulations in soft reds. Values are somewhat constrained, never reaching the darkest or lightest extremes. Saturation is likewise dampened; the brightest colors are muted and about a third of the painting is in very subtle chromatic grays that are nearly achromatic. The design, while essentially abstract, makes reference to natural forms and is occasionally explicitly floral. Lewis's delicate contours are enhanced by a finely tuned specificity of color.

This still image from the opening sequence of the animated program *Adventure Time* (fig. 10.11) uses color to establish mood. The scene, framed by a stony aperture of dark grays, depicts a landscape littered with cultural detritus in the aftermath of an apocalypse. A heavy blue-gray sky presses down on an earthy array of muted greens and browns struck here and there by a raking light. The values range from deep darkness to a few scattered notes of pale blue and yellow. Saturation is held largely to dull muted colors and chromatic grays, but accents of prismatic red, yellow, and magenta add spark.

10.12 Elizabeth Brandt, *Akimbo*, 2015, fiber. Collection of the artist.

In this richly colored stitched textile, Elizabeth Brandt uses a broad variety of colors, excluding only green and cool yellow from her palette (fig. 10.12). The most extreme hues are the complements blue and orange with reds and violets working as "bridge tones" to pull it all together. Every level of saturation is represented, as is a full range of values with the lightest tones assigned to smaller areas. The cut shapes, with their nuanced contours, are boldly but mindfully colored. The entire piece seems bathed in a warm, glowing light.

All of the color in this collage by Holly Roberts (fig. 10.13) is derived from red, yellow, and blue, the primary triad. But our customary cheerful associations with that trio are confounded here because the tones seem almost melancholy. The yellows are so drained of saturation that they barely register as such and the muted reds melt everywhere into grays. The imagery is similarly paradoxical, simultaneously comic and disturbing. Roberts negotiates between deliberate design and an embrace of pure chance to find revelation. A finely nuanced, equivocal use of color serves her expressive goals perfectly.

10.13 Holly Roberts, *Snake Daughter*, 2012, photography and paint on pane. Courtesy of the artist.

PART ELEVEN FREE STUDIES

IN PART ELEVEN YOU WILL

→ Apply what you have learned to images of your own design.

→ Critique your work with color vocabulary you have learned in this course.

→ Choose from past assignments those which might invite a second, deeper look.

→ Demonstrate your confidence and understanding of color.

I found I could say things with color and shapes that I couldn't say any other way – things I had no words for.
—Georgia O'Keeffe

MAKING FREE STUDIES

So far, the studies in this book have been tied to specific color concepts. But you might continue your color study through self-propelled free studies where you can elaborate on earlier assignments or branch out in a more general way to apply what you have learned. In this way you can build a bridge between the concepts you have encountered in the course and your own studio practice.

11.1A (opposite page), B and C Free studies will give you an opportunity to elaborate upon earlier assignments. Here are three that were developed from the saturation studies in Part Four. Kathleen Oberle.

When making free studies, use the same materials you have been using and continue to work small, mount them on card stock, and add them to your book/portfolio. Whereas up to now you have been making perfectly flat color, here you can experiment with a range of paint applications from thin, water-color-like washes to opaque, even physically textured paint. Or you might try introducing collaged elements from other sources such as photos or printed material. You can even use indirect techniques, e.g., stencils or rubber stamps. Consider working in small groups of two to five related studies to create variations on a theme. Figures 11.1–14 feature examples of free studies made by students in color workshops and classes to inspire your experimentation.

11.2 A complex study in progression. Kyuyeon Park.

11.3 This delicate study investigates the expressive potential of an analogous color scheme. Shirley Scheier.

11.4 This animated study uses precisely 10 colors. Notice the Albersian touch: the two yellow-green triangles are one color appearing as two. Siena Smith.

11.5 Another study that invites several dual readings of individual colors. Aaron Broadbent.

11.6 A composition of seven colors reminiscent of Matisse's paper cutouts. Mary Kuan.

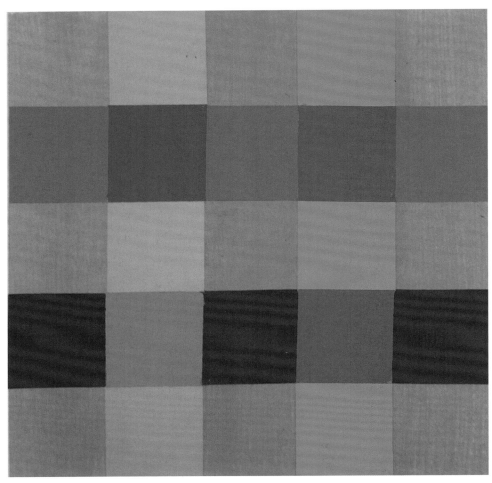

11.7 A subdued exploration of illusionistic transparency. Nathan Prebonick.

11.8 An architectural design provides a lucid structure to this study in analogous color. Kyuyeon Park.

11.9A, B Free studies are perhaps most rewarding when done as a related group. These two use the same six colors but invert their proportions dramatically. Lauren Demarco.

11.10A–C Each of these delicate studies uses watery veils of color to create its own quality of light. Ye Tian.

11.11A, B Using a palette knife to create tactile studies from few colors. Sarah Klotzer.

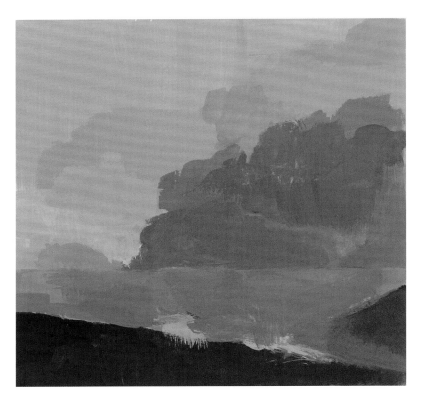

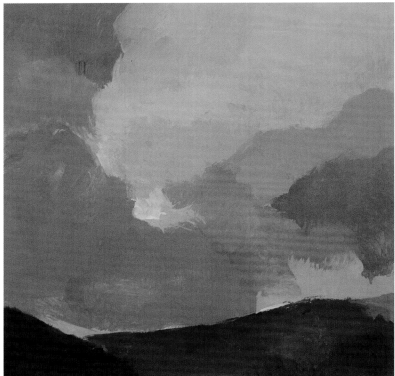

11.12A–D These four pictorial studies use color variation to depict four distinct light conditions. Syrena Li.

11.13A, B These geometric studies are enlivened by complementary color schemes. Lauren Delsignore.

11.14A, B Two subtle color studies made with found color from magazines. Katlyn Bensen-Crawford.

11.15 This digital study elaborates on the transparency assignments from Part Eight.
Digital design by author.

Free Studies in Adobe Photoshop

As with other studies, you can make your free studies in Photoshop. Working in layers makes it easy to create precise, complex designs. As before, build your studies from flat colored shapes, avoiding filters and "special effects." Figures 11.15–18 show three examples of digitally made free studies.

11.16 The goal here was to create a sense of light emanating from the center using color progression. Digital design by author.

11.17 This design explores color interaction: eight colors appear as sixteen.
Digital design by author.

11.18 Digital studies can be intricate, as in this progression study composed of many thin color strips to simulate a woven fabric. Digital design by author.

CONCLUSION

Color can play a vital role in your work whether you make it by hand or in a digital format. Through completing these assignments, you have greatly increased your understanding. Now the challenge is to integrate what you have learned into your art practice.

Artists and designers who master color ultimately transform their learning into what feels like intuition. Like an improvisational musician whose understanding of musical form seems utterly natural and spontaneous, the artist who masters color uses it freely and largely unconsciously to transmit ideas and emotions.

Develop and refine your thoughts and feelings about how color operates in the things you make. When you believe in the essential truthfulness of your point of view, your color will come alive.

ILLUSTRATED GLOSSARY

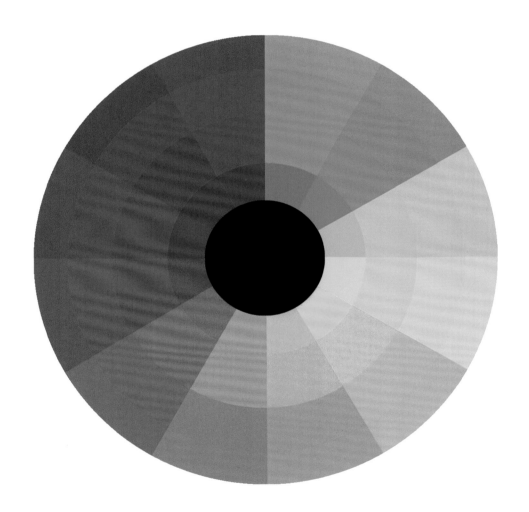

ACHROMATIC GRAYS

Achromatic means "without color." The term applies to grays made by combining black and white. Achromatic grays, like black and white, have no hue and no saturation – only value.

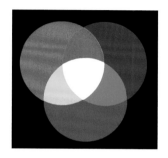

ADDITIVE COLOR

Color seen as light: additive color primaries are red, green, and blue. When they are combined the result is white light.

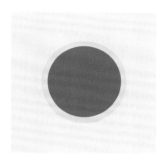

AFTERIMAGE

A common optical effect in which an additional color seems to appear at the edge of an observed color. When a color is placed against an achromatic background, its afterimage will be the color's complement.

ANALOGOUS

Analogous hues lie adjacent to each other on the spectrum.

BRIDGE TONES

Bridge tones provide a transition between disparate colors. In this example, the stark difference between a prismatic red at one end and a chromatic gray-green at the other is softened by a sequence of bridge tones that contain properties of both the red and the green.

CHROMATIC DARKS

Dark chromatic grays that have discernible temperature.

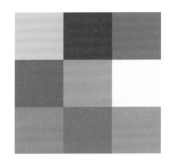

CHROMATIC GRAYS

Chromatic grays have relatively low saturation but discernible temperature and hue. (They are also called neutral tones.)

CMYK

CMYK refers to the colors used in four-color printing: cyan, magenta, yellow, and black (K).

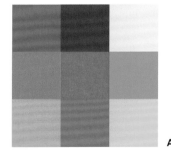

A

B

COLOR HARMONY

Color harmony is the character of the interrelationships in a group of colors. As with musical harmonies, color harmonies can be concordant or discordant, depending upon the relative cohesiveness of the color grouping. In the illustrations on the left, the colors in (A) are discordant and those in (B) are concordant.

COLOR INTERACTION

A color's character is dependent upon its context because colors interact with each other where they meet (see "simultaneous contrast"). In this example, the color in the center of each square is physically identical but appears different in each context.

COLOR SYMBOLISM

Color symbolism is based upon automatic associations attached to particular colors or color combinations that are learned and culturally determined. In this way colors are linked to abstract ideas, e.g., love, mortality, authority, or nationhood, as shown on the left.

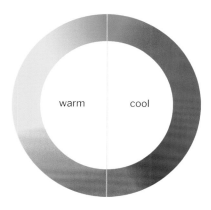

COLOR TEMPERATURE

When the hue continuum is represented as a circle, colors can be divided into cool and warm zones. The association of yellow, red, orange, and yellow-green with warmth and violet, blue, and blue-green with coolness is probably based on physical experience.

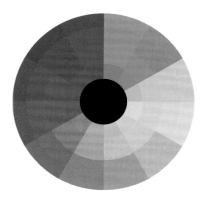

COLOR WHEEL

The color wheel is any circular depiction of the hue continuum and has been used for centuries by color theorists. The version here (the red, yellow, and blue color wheel) is divided into 12 major hues that include primary, secondary, and tertiary colors. This wheel is also separated into four rings that indicate four levels of saturation: prismatic color, muted color, chromatic gray, and achromatic gray.

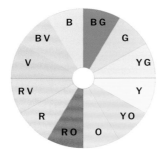

COMPLEMENTARY HUES

Complements are any two hues that lie directly opposite each other on a color wheel. All hues have a complementary partner. In the RYB model, when complements are intermixed, the resulting color is darker and duller than either of the two complements. When juxtaposed, they energize each other.

CO-PRIMARIES

Co-primaries expand the primary triad of red, yellow, and blue into three pairs that include warm and cool versions of each color. The use of co-primaries greatly extends the potential range of tones achieved through their intermixture.

DARK TRANSPARENCY

Dark transparency is an illusionistic transparency wherein the color at the "overlay" is darker in value than both of the parent colors. The hue of the central color should blend that of each parent color equally. The illusion is more effective when the two colors that appear to overlap are close in value.

EARTH TONE PRIMARY TRIAD

An earth tone primary triad consists of earth tones, e.g., burnt sienna, yellow ocher, and a blue-gray (e.g., Payne's gray). When intermixing this primary triad, no prismatic color can result.

GAMUT

In computer terminology, a gamut is the range of hues available to a particular mode. The diagram on the left represents three color gamuts. The visible spectrum is represented by the large, solid shape, RGB by the pink triangle, and CMYK by the area bound in yellow.

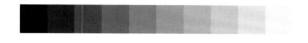

GRAYSCALE

The grayscale is a representation of the complete value continuum broken down into a finite number of steps. It usually consists of ten or eleven distinct and evenly progressing achromatic grays.

HUE

One of the three structural attributes of color (along with value and saturation), hue is the name we assign to a color based upon its location on the color spectrum.

HUE CONTINUUM

The hue continuum is a graphic representation of the full color spectrum from infrared to ultraviolet.

INHERENT LIGHT

Unlike luminosity, which is based on value and is measurable, inherent light is a visual quality that depends upon relative saturation and context. In the example on the left, the colors gain saturation as they move toward the center square, demonstrating a build-up of inherent light.

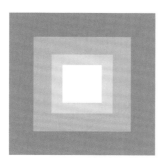

LUMINOSITY

Luminosity is light reflected from a surface; in color, it is tied to value. The lighter the color, the more luminous it is. This can be measured with a light sensor. In the example on the left, luminosity builds as the colors progress toward the center of the square.

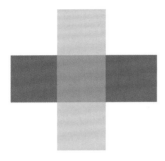

MEDIAN TRANSPARENCY

Median transparency is an illusionistic transparency wherein the color at the "overlay" is precisely halfway between both of the parent colors in value. The hue of the central color should blend that of each parent color equally. The illusion is more effective when the two colors that appear to overlap are disparate in value.

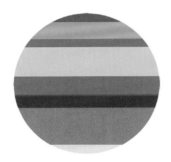

MONOCHROMATIC

Monochromatic color schemes are limited to one hue and tones derived therefrom. These tones can have a broad range of values or saturation levels, as shown here.

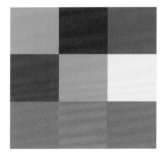

MUTED COLORS

Muted colors constitute a zone in the saturation continuum that falls between chromatic grays and prismatic colors. Muted colors can be characterized as softer than prismatic colors, but they still display a clear sense of hue identity.

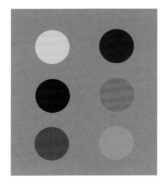

NONPROPORTIONAL COLOR INVENTORY

This is a selection of colors drawn from an object or image that has an uncountable number of colors. The inventory should be a summation of the color in the source that expresses its entire chromatic range as well as possible in a few tones.

OVERTONE

Overtone is a term borrowed from music that describes the secondary hue bias or leaning of a primary hue. For example, alizarin crimson is a red that leans toward violet; it has violet overtones. Scarlet, another red, has orange overtones. An awareness of overtone is helpful in color mixing. The illustration on the left shows cool primary hues (crimson, lemon yellow, and ultramarine) surrounded by their overtone colors.

PRIMARY TRIAD

The primary triad forms an equilateral triangle on the color wheel and, in theory, can generate all colors. The scientifically accurate primary triad is cyan, magenta, and yellow, but the traditional version (red, yellow, and blue) has practical advantages that keep it in favor with many artists and designers. This workshop is based upon the RYB primary triad.

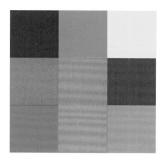

PRISMATIC COLORS

Prismatic colors are the purest version of spectral hues available in pigments.

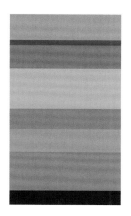

PROPORTIONAL COLOR INVENTORY

The proportional color inventory is based on an object or image that has a countable number of colors. It represents all the colors present in their relative proportions.

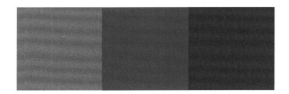

RGB

In additive or light color theory, red, green, and blue are considered the primary colors. These colors match the cone-shaped light sensitive cells in the human eye.

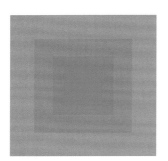

SATURATION

Saturation is the relative purity of hue present in a color. Highly saturated colors are very rich and have a strong hue presence. Colors that are low in saturation are dull and have a weak discernible hue. In this course we recognize three levels of saturation: prismatic color, muted color, and chromatic gray. In the image on the left, the colors of the square become more saturated as they move toward the center. Saturation is sometimes called "intensity" or "chroma."

SATURATION CONTINUUM

The saturation continuum represents the infinite levels of saturation that exist between any two intermixed complementary colors.

SECONDARY TRIAD

In the RYB primary system, the secondary triad consists of green, orange, and violet. Each of these colors can be mixed by combining two primary colors.

SHADE

A shade is the result of mixing any color with black.

SIMULTANEOUS CONTRAST

Simultaneous contrast is the optical effect that two neighboring colors have upon each other as their afterimages interact along a shared border. The image on the left illustrates the afterimages a violet and yellow-orange would project upon each other where they meet.

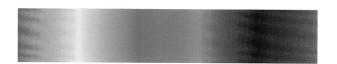

SPECTRUM

The spectrum is a phenomenon of light and can be seen in a rainbow or in the colors a prism casts upon a wall. It contains the full range of hues present in sunlight (see "hue continuum").

SUBTRACTIVE COLOR

Subtractive color theory applies to color as manifested by reflected, rather than direct light.

TERTIARY COLORS

These are also called "intermediate colors" and are yellow-orange, red-orange, blue-green, yellow-green, blue-violet, and red-violet. In the illustration on the left, the tertiary colors at the top and bottom of the grid surround the three secondary colors to which they are related.

TINT

A tint results when any color is mixed with white.

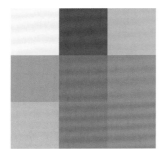

TONE

Tone is a somewhat imprecise term that we use to refer to any color but a prismatic color. All muted colors and chromatic grays are tones, as are all tints and shades.

TRIADIC

Triadic color relationships are comprised of any three equidistant hues on the color wheel. The two named triads are the primary and secondary. The illustration on the left shows the location of the primary triad on the hue spectrum.

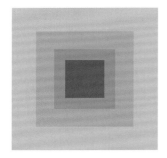

VALUE

Value is the relative quality of lightness or darkness in a color. It is the only structural factor of color visible in achromatic settings, as in black-and-white photography or in grayscale mode. Value means luminosity. In the image on the left, the colors become progressively darker in value (and less luminous) as they approach the center of the square.

VALUE CONTINUUM

The value continuum is a graphic representation which suggests the infinite values that exist between black and white.

BIBLIOGRAPHY

Albers, Josef. *Interaction of Color.* New Haven, Conn.: Yale University Press, 1963.

Arnheim, Rudolf. *Art and Visual Perception.* Berkeley, Ca.: University of California Press, 1965.

Batchelor, David. *Chromophobia.* London: Reaktion Books, 2000.

Birren, Faber. *Principles of Color.* New York, N.Y.: Van Nostrand Reinhold Company, 1969.

Bloomer, Carolyn M. *Principles of Visual Perception.* New York, N.Y.: Design Press, 1990.

Ferris, William. *Local Color: A Sense of Place in Folk Art.* New York, N.Y.: Anchor Books, 1992.

Flam, Jack. *Matisse on Art.* New York, N.Y.: E.P. Dutton, 1978.

Gage, John. *Color and Culture: Practice and Meaning from Antiquity to Abstraction.* Boston, Ma.: Bulfinch Press, 1993.

Goethe, J.W. *Theory of Colors.* Cambridge, Mass.: MIT Press, 1970.

Haftman, Werner. *The Mind and Work of Paul Klee.* New York, N.Y.: Praeger, 1967.

Itten, Johannes. *The Art of Color.* Translated by Ernst van Haagen. New York, N.Y.: Van Nostrand Reinhold Company, 1973.

Kandinsky, Wassily. *Concerning the Spiritual in Art.* Translated by Sadler. New York, N.Y.: Dover Publications, 1977.

Muncell, A.H. *A Color Notation: An Illustrated System Defining All Colors and Their Relations by Measured Scales of Hue, Value, and Chroma.* Baltimore, Md.: Munsell Color Company, 1905.

Newton, Sir Isaac. *Opticks, or a Treatise of the Reflections, Inflections & Colours of Light* (1704). 4th ed. New York, N.Y.: Dover Publications, 1952.

Osborne, Roy. *Color Influencing Form.* 2nd ed. London: Thylesius Books, 2016

Osborne, Roy. *Lights & Pigments: Color Principles for Artists.* London: John Murray Publishers Ltd, 1980

Ostwald, Wilhelm. *The Color Primer.* Edited by Faber Birren. New York, N.Y.: Van Nostrand Reinhold Company, 1969.

Rood, Ogden N. *Colour: A Textbook of Modern Chromatics.* London: Kegan Paul, Trench, Trubner & Co. Ltd., 1904.

Shorr, Harriet. *The Artist's Eye.* New York, N.Y.: Watson-Guptill Publications, 1990.

Sloane, Patricia. *The Visual Nature of Color.* New York, N.Y.: Design Press, 1989.

St. Clair, Kassia. *The Secret Lives of Color.* New York, N.Y.: Penguin Books, 2017.

Tufte, Edward R. *Envisioning Information.* Cheshire, Conn.: Graphis Press, 1990.

Van Gogh, Vincent. *The Letters of Vincent van Gogh.* Boston, Mass.: New York Graphic Society, 1981.

Wollheim, Richard. *On Art and the Mind.* Cambridge, Mass.: Harvard University Press, 1974.

CREDITS

PART ONE

1.8 National Gallery of Art, Washington.
1.9 © Paul M.R. Maeyaert.

PART FOUR

4.16 Private collection, London. **4.17** and **4.18** Museo
Morandi, Bologna. © DACS 2019. **4.20** Ellsworth Kelly,
Red Blue Green, 1963, oil on canvas. 83⅝ x 135⅞ in (212.4 x
345.1 cm). Collection Museum of Contemporary Art, San
Diego. Gift of Dr and Mrs Jack M. Farris, 1978.3. © Ellsworth
Kelly Foundation; image courtesy Museum of Contemporary
Art, San Diego EK 316. **4.21** Accession no. 2004.2.1. Photo:
Charles Bechtold. © 2019 American FolkArt Museum/Art
Resource, NY/Scala, Florence.

PART FIVE

5.6 Bex Glendining, *Night Street*, 2018. © Bex Glendining.
5.10 135620116 © Ankmsn/Dreamstime.

PART EIGHT

8.9 Ravenna © José Luiz Bernardes Ribeiro/CC BY-SA 4.0.
8.10 © The Estate of Euan Uglow/Bridgeman Images.
8.17 Museum purchase from Friends of Textiles Fund
(1978-102-1). Photo: Matt Flynn © Smithsonian Institution
New York, Cooper-Hewitt- Smithsonian Design Museum.
© 2019/Art Resource, NY/Scala, Florence.
8.30 Purchase with funds from the Members Guild
and through exchange Accession # 69.42. Photo courtesy
High Museum of Art, Atlanta, GA. **8.31** Edith and Milton
Lowenthal Collection, Bequest of Edith Abrahamson
Lowenthal, 1991.

PART TEN

10.1 Courtesy of the artist and Sprüth Magers.
10.9 National Gallery of Art, Washington.

INDEX

INDEX (CONTINUED)

INDEX (CONTINUED)